IMAGES
of America

ROOSEVELT ISLAND

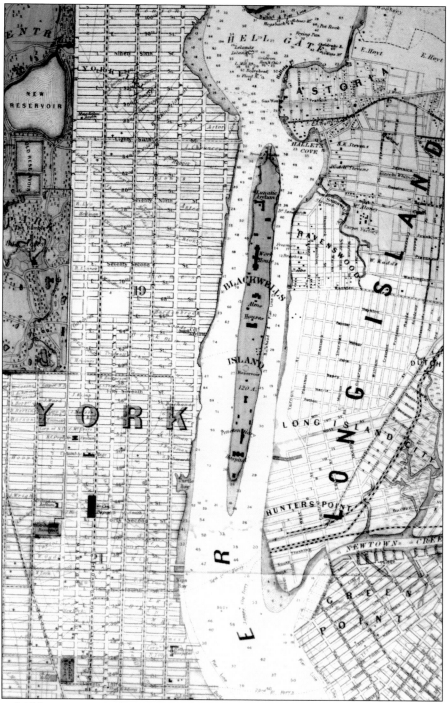

This mid-19th-century map shows Roosevelt Island (then Blackwell's Island) between Manhattan and Long Island in the East River. Two miles long and 800 feet wide, it runs parallel to Manhattan between 46th and 86th Streets. The locations of some early institutions—the penitentiary, the workhouse, the almshouse, and the asylum—are indicated. (Roosevelt Island Historical Society.)

IMAGES
of America

ROOSEVELT ISLAND

Judith Berdy and the
Roosevelt Island Historical Society

ARCADIA
PUBLISHING

Published by Arcadia Publishing
Charleston, South Carolina

Printed in the United States of America

Library of Congress Catalog Card Number: 2003105199

For all general information contact Arcadia Publishing at:
Telephone 843-853-2070
Fax 843-853-0044
E-mail sales@arcadiapublishing.com
For customer service and orders:
Toll-Free 1-888-313-2665

Visit us on the Internet at www.arcadiapublishing.com

CONTENTS

ACKNOWLEDGMENTS

Special thanks go to many people who assisted us and made the project possible: Ursula Beau-Seigneur, who transcribed the text; Maria Harrison, who fit all the material into a great layout and performed computer magic to transform the images into bits and bytes; and Katherine Vithlani and Vicki Feinmel for helping select the images and organize the book into chapters.

Our first contributor was Rev. Oliver Chapin, who lived on the island for 35 years and collected historical photographs and memorabilia. We extend our special thanks to his family for use of the material from the Oliver Chapin Collection.

Thanks to David Blackwell and his family for maintaining and sharing their family history with us and to Geniza Madden and Eleanor Schetlin for being children on the island and bringing their stories of Welfare Island to us.

Thanks to Thomas McCarthy and the New York Corrections Historical Society, who shared so much workhouse and penitentiary history with us.

The collections of the New York City Municipal Archives and director Kenneth Cobb generously gave us access to their records.

Thanks to Elizabeth Barlow for her book *The Forests and Wetlands of New York City* and to *The Island Nobody Knows*, compiled by the Welfare Island Development Corporation in 1969. Thanks to Anne Kayser, who came to the island in the 1960s and took magnificent photographs of the abandoned isle.

Thanks to the library at the Metropolitan Hospital Center and Antoinette Drago, its senior librarian, for starting us on the path to learn the history of this great hospital.

Thank to our local island newspaper, the *Main Street Wire*, whose publisher, Dick Lutz, shared with us photographs, the invaluable *Encyclopedia of the City of New York*, *The Epic of New York City*, and *The A.I.A. Guide to New York* for those great statistics we used so freely.

The archives of St. Joseph's Seminary, the Episcopal Diocese of New York, and the Rabbis of Coler-Goldwater Jewish Chapels all contributed information on the religious history of the island.

Thanks to the Roosevelt Island Operating Corporation and the Empire State Development Corporation (the successor agency to the Urban Development Corporation) for archival photographs of the island and to Neil Tandon, who worked so hard to put together a walking tour of the island with Roosevelt Island Operating Corporation and the Roosevelt Island Historical Society.

Thanks to the architects and developers who shared their work: Page Ayers Cowley, the Hudson Companies and the Related Company, and Becker and Becker.

Thanks to Charlie Gelati, who brought us wonderful snapshots of his mother while she studied, lived, and worked on the island.

Thanks to Speedy Berdy, Catherine Kehoe, and Bustapher Jones, who could take an entire hour's worth of work and with a flick of a paw give it their approval (or just sit on it).

Thanks to all our visitors and correspondents who bring us their stories of life on the island. It is impossible to name every person and organization. The history of the island is like a great jigsaw puzzle that we are constantly adding pieces to.

—Judith Berdy and the Roosevelt Island Historical Society

INTRODUCTION

Islands always seem to have their own personality, and Roosevelt Island, the third largest island in New York City, possesses a unique one. As one of the many islands that form New York City, Roosevelt Island was molded by glacial erosion thousands of years ago and is blessed with a temperate climate, rivers of clean, fresh water, sheltered coves, and deepwater harbors with access to the Atlantic Ocean. These ideal conditions have invited human habitation and activity for thousands of years.

This book begins in the pre-Colonial period, when the island was bought from the Native Americans (1633) and confiscated by Peter Stuyvesant (1652), who gave it to Frances Fyn. The island was then confiscated by the British and given to Capt. John Manning, whose daughter married a Robert Blackwell, whose descendants sold it to the city of New York. The city then leased it to the state.

Through the years, the island has been at the mercy of the city politic. When space was needed for almshouses, prisons, hospitals, and an asylum, the city bought the island. After the institutions closed, the island was abandoned for several years until the city and state determined that there was a housing crisis. The island was awakened, a new community was built, and so the story continues.

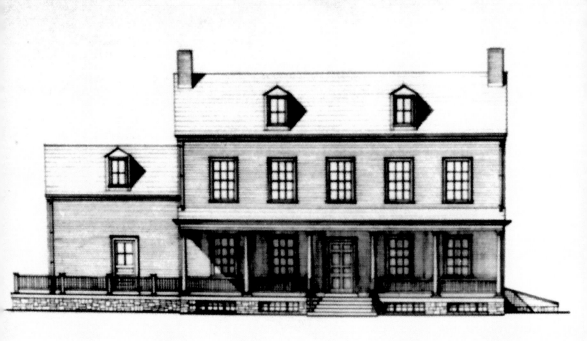

This rendering of Blackwell House was done by architect Georgio Cavaglieri for the 1970s restoration of this landmark farmhouse. This view shows the front porch that faces Queens. (Roosevelt Island Historical Society.)

One

THE BEGINNING

Roosevelt Island is an island with many names. It was originally called Minnahanonck, or "nice island," by the Native Americans who fished from its shores, hunted game, and gathered berries and other foods in its lush forest.

In May 1623, the Dutch West India Company brought the first settlers to this area. Many of them settled along the East River since this area was protected from the fierce winter winds that blew up the Hudson River. In 1633, Wouter Van Twiller was appointed the Dutch governor and soon persuaded the Native Americans to sell him large tracks of land. One of the properties purchased was the 128-acre, two-mile-long Minnahanonck Island. The resourceful Dutch colonists found the small island just east of Manhattan a convenient location to raise hogs for their tables, so this place became known as *Varckens* (Hogs Island). Van Twiller lost the respect of the colonists and was dismissed. Peter Stuyvesant became governor in 1647 and five years later declared the claim to the island by Van Twiller void. Stuyvesant realized that the Dutch and the English were on a collision course. He planned to construct fortifications on the island and granted it to Capt. Francis Fyn.

European settlers, mainly from England, continued to arrive, and tensions increased over who would control the New World. Ultimately, Britain won the struggle. All Dutch lands came under rule of King Charles II. In 1664, he gave his brother James, who later became King James II, Long Island and its neighboring islands. He, in turn, awarded Capt. John Manning, who was sheriff of New York, Varckens Island for loyalty to the Crown. The island became known as Manning's Island. However, Manning's glory was short lived. He was tried for cowardice and treason. Spared execution, he retired to his island and spent the final years of his life in comfort.

When he died in 1685, the island was inherited by his stepdaughter, Mary Manningham, wife of Robert Blackwell. Thus, the island became Blackwell's Island, a name that would remain until 1921. In 1796, a modest clapboard cottage was built for the Blackwell family. This 18th-century building still stands and is the sixth oldest farmhouse in New York City. Periodic attempts were made to sell the island, but it remained in the hands of the Blackwell family until 1823, when the city of New York found a need for it.

By 1820, with 123,706 citizens, New York City was the most populous city in the nation. However, this expansion came at a price. Crime, poverty, and threats to public health had also increased. To preserve the social order, city leaders began to purchase small islands, such as Blackwell's, and built institutions to contain the sick, the criminal, and the indigent.

In 1828, the governor of New York, Philip Hone, was impressed by the quality of the building stone on Blackwell's Island. He proposed that a penitentiary be constructed on the island. The Blackwell family had finally found a buyer. The city of New York paid the princely sum of $32,000 for the land. Blackwell's Island was the first of many small islands purchased by the city to address social problems created in part by an exploding population and lack of any governmental agencies to deal effectively with such problems. The city leaders insisted that institutions, located on quiet islands, would be places where the sick would be cared for in a

healthful environment and the criminal would have an ordered place to reconsider his or her actions. As the most prosperous city in the nation at the time, the city hired the century's top architects to design the charitable and corrective institutions. The cornerstone for a prison was laid in September 1828. The facility opened in 1832, and its vast wings ran north to south in the center of the island.

The New York City Lunatic Asylum, which opened in 1841, provided relief to the overcrowded units at Bellevue Hospital in Manhattan. The asylum was designed by Alexander Jackson Davis as an octagon-shaped building for the main entrance and administrative center with four wings of patient units jutting off the center. Only two wings were completed. The rotunda was later crowned with an impressive dome designed by Joseph Dunn. Tragically, administration of the facility and patient care in no measure matched the beauty of the structure. The asylum was soon crowded with twice the number of people it was designed to hold. Convicts from the penitentiary were assigned to provide nursing care and supervision for the patients.

Construction of institutions continued at a steady pace. Penitentiary Hospital, which treated patients with venereal diseases, opened in 1849. Eight years later, Charity Hospital, later renamed City Hospital, was built. The first of New York City's almshouses opened in 1850 as a temporary home for the thousands of destitute people. Soon, many other almshouses were built with separate quarters for men and women. In the center of this complex, the Chapel of the Good Shepherd was constructed. It was but the first of several chapels built to serve the spiritual needs of the patients and residents at the institutions.

The workhouse, built as a minimum-security prison, opened 1850. There, inmates served short sentences for petty crimes such as prostitution and drunkenness.

Designed by James Renwick Jr., the Smallpox Hospital opened 1856. It was the first hospital in the United States to receive patients afflicted with smallpox. By law, all city residents who contracted this deadly disease were quarantined on Blackwell's Island regardless of social status. After the development and distribution of a successful vaccine, the hospital closed in the late 1800s.

It remained unused until 1902, when it reopened to house the New York School of Nursing. The school continued with its mission for more than 50 years. By 1872, there were 11 institutions operating on Blackwell's Island. Little remained, except Blackwell House, of the once bucolic environment.

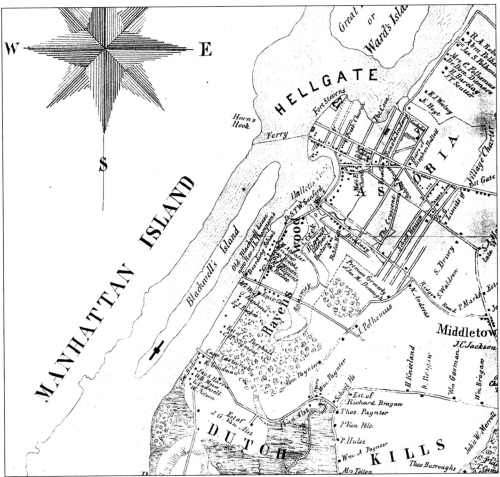

This map shows Blackwell's Island in relation to Brooklyn and Queens. The island's owners, the Blackwell family, lived in Queens and farmed on the island. At that time, farms and mansions occupied the shores of Queens. Blackwell's Island was a strategic location during the Revolutionary War, and Fort Stevens to the north protected it. (Roosevelt Island Historical Society.)

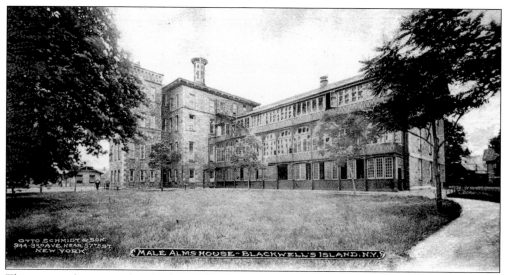

This postcard pictures the almshouse for men. The exterior of these buildings was attractive, but as Charles Dickens wrote, "it is badly ventilated, and badly lighted; was not too clean; and impressed me, on the whole, very uncomfortably." (Roosevelt Island Historical Society.)

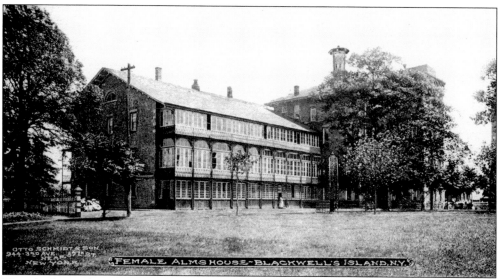

The almshouse for women is shown in this postcard view. The prison uniform consisted of striped ticking dresses and a large bonnet, which obstructed peripheral vision. Thin woolen shawls were issued to protect the inmates from the cold winds that swept up the East River. (Roosevelt Island Historical Society.)

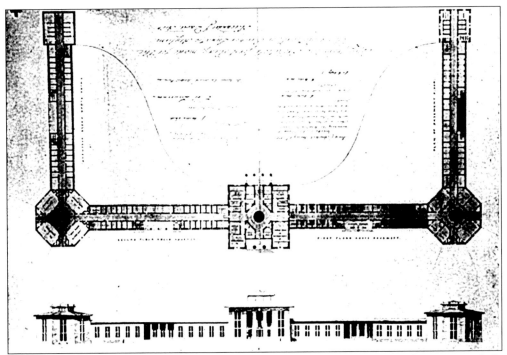

This 1833 sketch pictures the asylum as proposed by architect Alexander Jackson Davis. Only the west and south wings of the Octagon Tower were actually constructed. Three-story-high wings converged at the Octagon Tower, the main entrance and administrative center of the hospital. Architectural historians have noted that the tower was the grandest interior of the city at that time. (Courtesy A.J. Davis Collection, New-York Historical Society.)

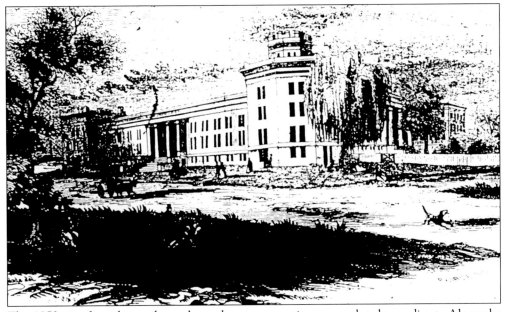

This 1853 view from the northeast shows the structure as it was completed according to Alexander Jackson Davis's original plan. (*Gleason's Pictorial,* Roosevelt Island Historical Society.)

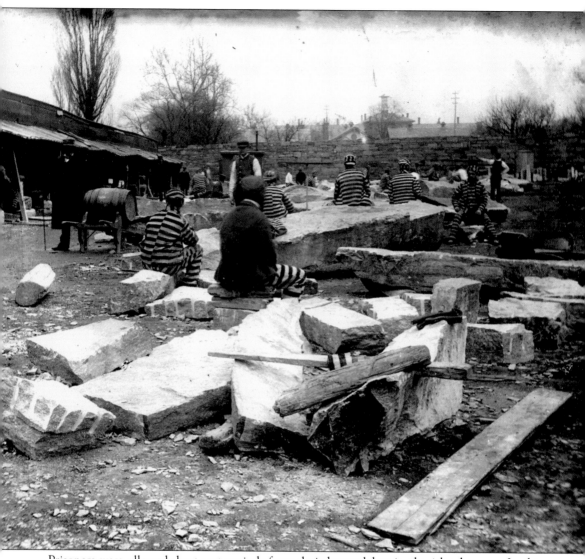

Prisoners were allowed short rest periods from their heavy labor in the island quarry. In this image, the walls of the quarry are approximately 10 to 12 feet deep. Eventually, the depth reached 50 feet, indicating the massive amount of stone removed for construction on the island. (Courtesy Jacob A. Riis Collection, Museum of the City of New York.)

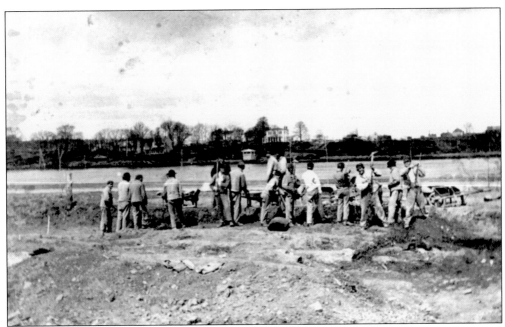

Labor gangs were used throughout the island for construction, maintenance, and general services. The island was noted for its well-kept lawns and beautiful gardens, all provided for by unpaid laborers. (Oliver Chapin Collection, Roosevelt Island Historical Society.)

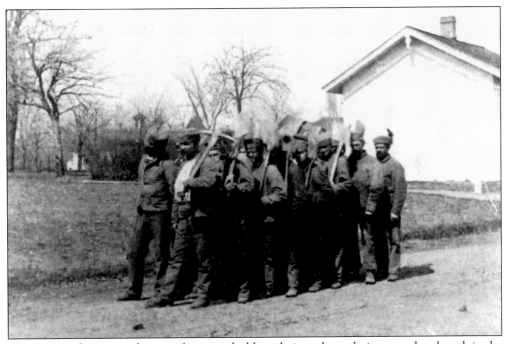

This picture shows a work gang of inmates holding their tools on their way to break rock in the quarry. The prisoners in the penitentiary served longer sentences than those in the workhouse, and thus, if physically able, they were the ones selected to do the heavy work. (Courtesy Byron Collection, Museum of the City of New York.)

This picture shows the Blackwell's Island Penitentiary under construction. It was designed by James Renwick, who loved to include gothic influences in his work. Other structures on the island, the Smallpox Hospital and the lighthouse, are easily identified as being of his design. (Oliver Chapin Collection, Roosevelt Island Historical Society.)

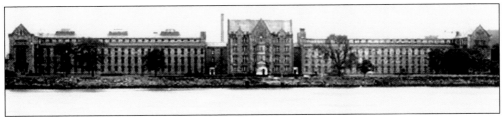

The workhouse was constructed in 1852 as a minimum-security prison. It housed persons serving short sentences, five days to one year, for crimes such as prostitution, alcoholism, and petty theft. Inmates were classified into four categories: able-bodied men, men able to perform light labor and serve as orderlies in the hospitals, men able to sweep the grounds, and men exempt from labor due to disease or old age. At any one time, there were approximately 1,000 men incarcerated in the workhouse. (Courtesy Correctional Photograph Archive.)

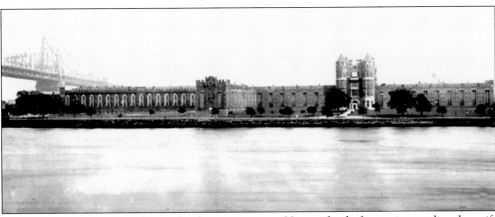

James Renwick was the architect for the penitentiary. He was fond of injecting medieval motifs into his castlelike structures. This structure is typical of many buildings designed by him. (Courtesy Correctional Photograph Archive.)

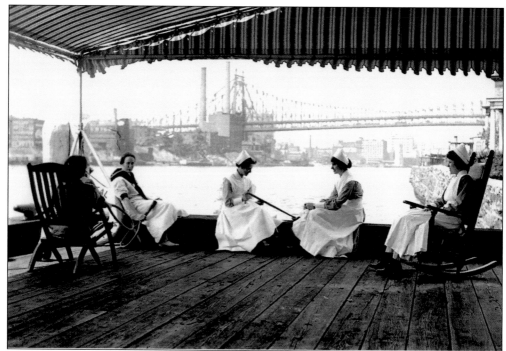

The New York City Training School for Nurses opened in 1879 in the building vacated by the Smallpox Hospital. This view, looking north toward the Queensboro Bridge, shows the nurses at rest on a pier after a long day. (Courtesy New York City Municipal Archives.)

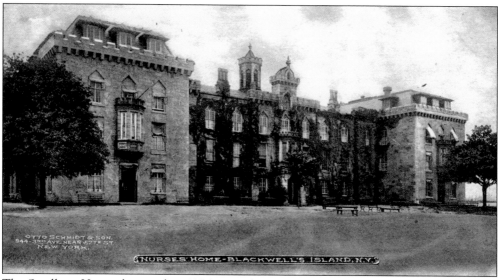

The Smallpox Hospital opened in 1856, according to a design by James Renwick. It was one of the few institutions that cared for private as well as charity patients. To protect the public health, all persons who contracted a contagious disease were quarantined on the island. The hospital closed in the 1870s, and the building was then occupied by the nation's third school of nursing, the New York City Training School for Nurses. (Otto Schmidt & Son, Roosevelt Island Historical Society.)

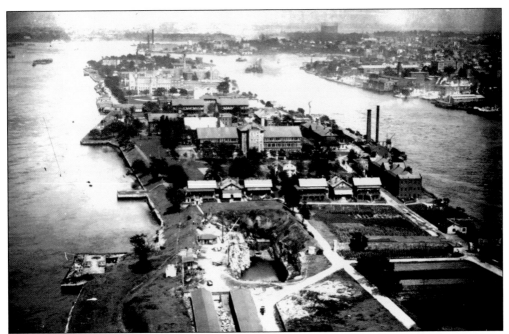

This view looks north from the Queensboro Bridge in 1907. Note the open quarry in the foreground and Cottage Row, the residences built for senior staff of the institutions. (Copyright George G. Bain.)

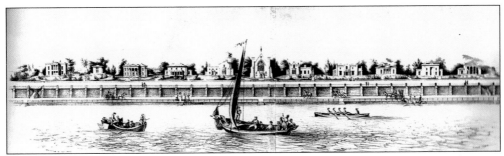

This is Alexander Jackson Davis's design for housing in Ravenswood, Queens, directly across the East River from Blackwell's Island. Davis envisioned luxurious mansions lining the shore of the river. This project was never completed. (Courtesy A.J. Davis Collection, New York Historical Society.)

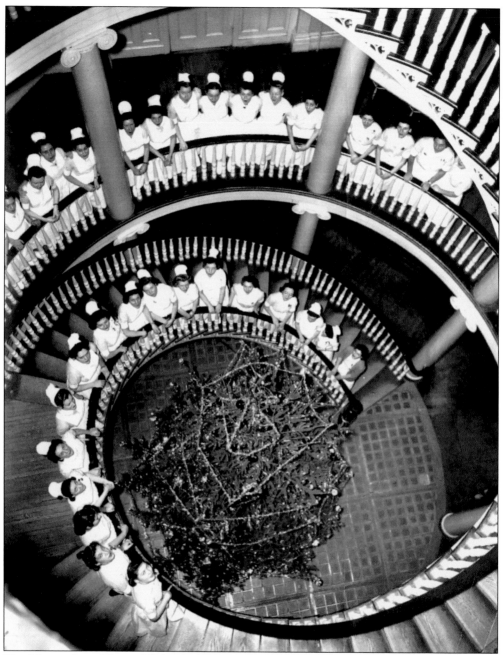

The Metropolitan Hospital School of Nursing provided training for young women. Every year at Christmas, the nurses would sing chorales in the rotunda. Note the elaborately decorated Christmas tree at the base of the grand staircase. The school was on the island from 1895 through 1955. (Metropolitan Hospital Center Archives.)

Two

METROPOLITAN HOSPITAL

In 1894, Homeopathic Hospital relocated from Ward's Island to Blackwell's Island. The hospital changed its name to Metropolitan Hospital when it moved to the buildings vacated by the asylum. The staff was appalled to find that their new quarters had been ransacked by the former occupants. It took over a year to refurbish the facility, build modern operating theaters, and upgrade the patient units. Together with the island's City Hospital, these facilities formed two of the world's largest medical institutions. Combined, they had the capacity to treat 1,400 patients.

Metropolitan Hospital was a general hospital specializing in the treatment of tuberculosis. In spite of the hospital's capacity to treat large numbers of patients, there were periods when epidemics of committable diseases swept through crowded New York City. To handle the additional patients, circus tents were erected on the grounds next to the hospital. When the crisis abated, the tents were folded and burned as an infection-control measure.

In the 1880s, the first steamer, the *Minnahanonck*, was put into service carrying patients and staff to the island. It made two daily trips from Bellevue's dock at 26th Street. Later, a hospital reception area and dock were built at East 70th Street in Manhattan, and two small steamers ferried people across the East River. Upon arrival, patients were taken off the boat and placed in an ambulance for the short ride to the hospital. The *Welfare*, the last steamer to serve the island, ceased operation in 1955, with the opening of the Welfare Island Bridge, which linked the island to Queens.

Metropolitan Hospital was affiliated with Flower Fifth Avenue Hospital and New York Medical College and served as a training ground for their students. It was one of the city's important teaching hospitals for physicians, nurses, and allied healthcare workers. In 1955, the hospital closed and relocated to new quarters in Manhattan. The building's two wings were demolished, leaving only the Octagon Tower standing. Although it was declared a city landmark in 1975, the empty structure soon became a target for vandals. Over the years, two fires and exposure to the elements caused extensive damage to the once magnificent rotunda.

Metropolitan Hospital School of Nursing opened in 1892. Each year, dozens of young women came to Blackwell's Island to study nursing. They lived and studied in a gracious but homey residence called Draper Hall and practiced, under supervision, in the hospital. Although the training was demanding, the island was a lovely place to live. Just north of the hospital was a park with lush gardens, stunning vistas, and a small lighthouse. Also, Manhattan was just a short boat ride away. Correspondence from this period speaks of high jinks, forming lifelong friendships, and late-night rushes to catch the last ferryboat.

In 1894, Metropolitan Hospital occupied the facility vacated by the city asylum. It vastly expanded and improved this building for use as a general medical and surgical hospital with a specialty in treating tuberculosis. It was one of the world's largest medical institutions. (Courtesy New-York Historical Society.)

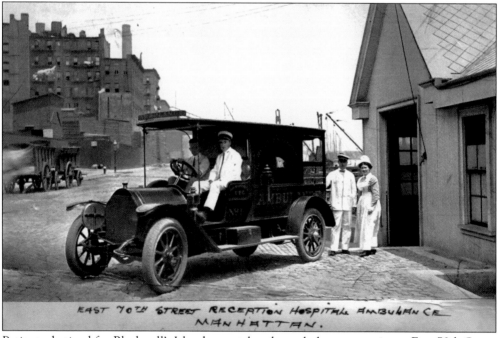

Patients destined for Blackwell's Island were taken by ambulance to a pier at East 70th Street in Manhattan and placed on a ferryboat. Waiting ambulances then delivered them to the appropriate hospital on the island. (Courtesy New York City Municipal Archives.)

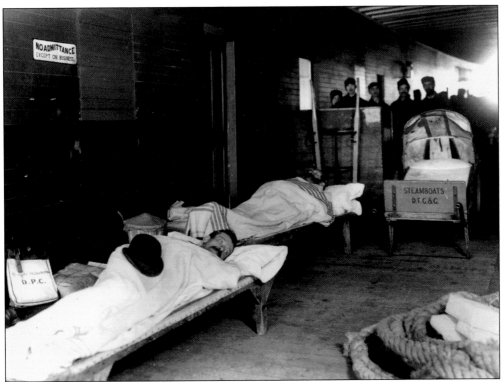

Patients were transported to Metropolitan Hospital by ferry. (Courtesy Byron Collection, Museum of the City of New York.)

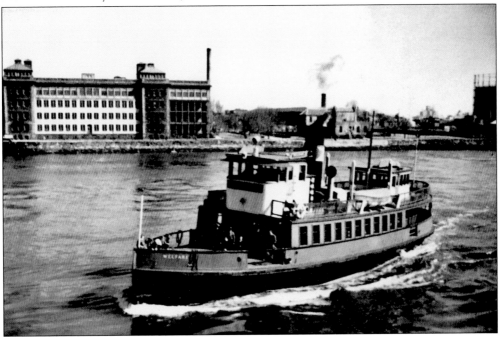

The ferryboat *Welfare* crossed the East River from East 78th Street in Manhattan to the island, transporting patients, staff, and visitors. (Courtesy Gibbs Marine.)

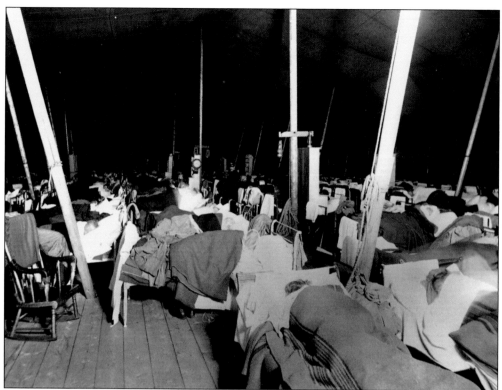

This is an interior view of the tuberculosis quarantine tents used during epidemics. (Courtesy Byron Collection, Museum of the City of New York.)

The quarantine tents were burned after epidemics ended. (Courtesy Byron Collection, Museum of the City of New York.)

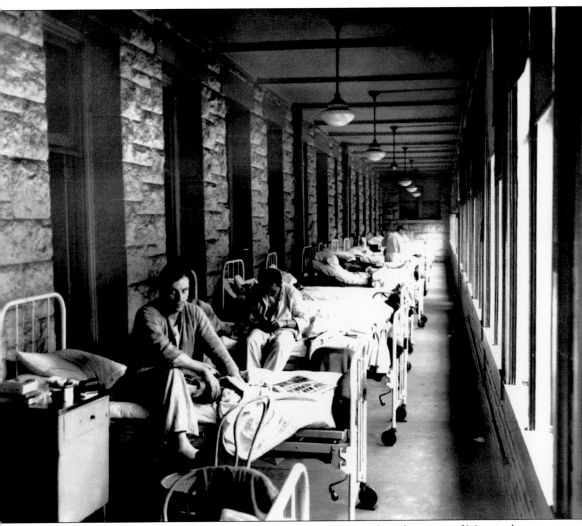

During the hot summer months, the beds were rolled out on the broad terraces of Metropolitan Hospital. Prior to air-conditioning, this was the only way to offer the patients some relief from the heat and humidity. Note the wall of gray gneiss behind the patients. It was used as building blocks for all institutions on the island. (Courtesy New York City Municipal Archives.)

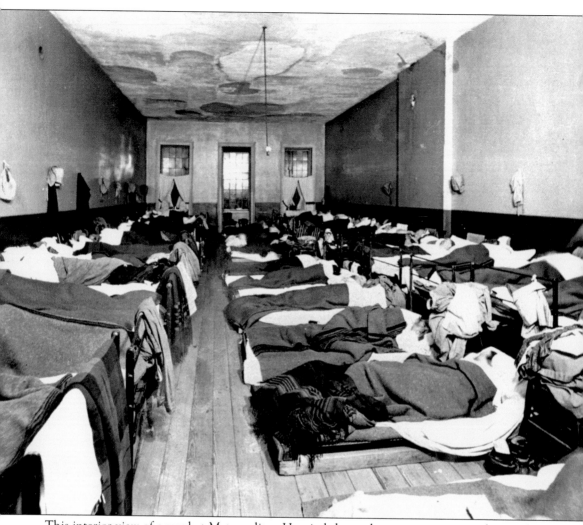

This interior view of a ward at Metropolitan Hospital shows the extreme overcrowding at the facility. (Roosevelt Island Historical Society.)

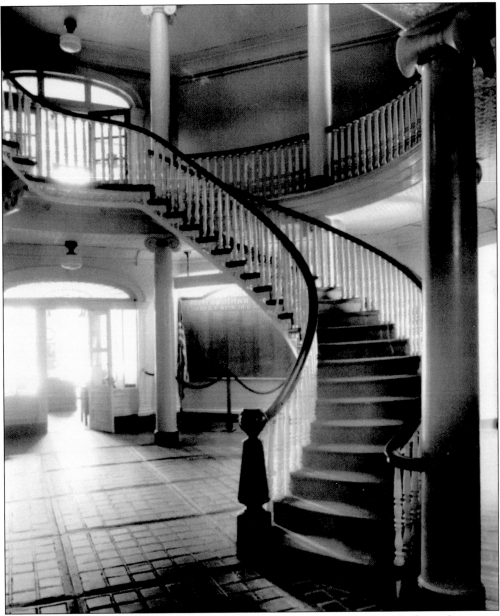

The interior of Metropolitan Hospital is famous for its rotunda and worked-metal staircase designed by Alexander Jackson Davis. The glass-brick floor on the main level is lit from below. (Courtesy New York City Municipal Archives.)

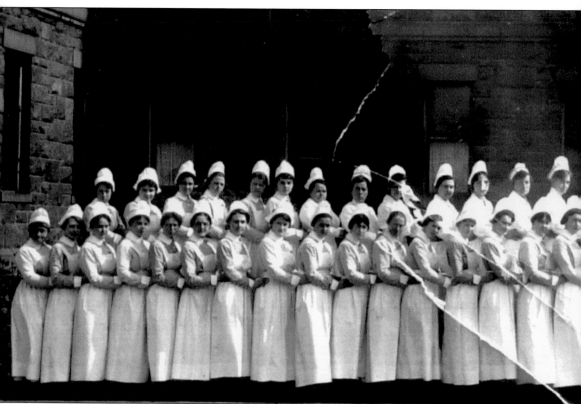

Shown here are student nurses from Metropolitan Hospital School of Nursing standing in front

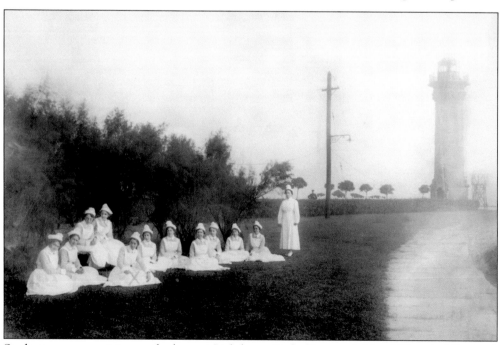

Student nurses are sitting on the lawn at Lighthouse Park. (Roosevelt Island Historical Society.)

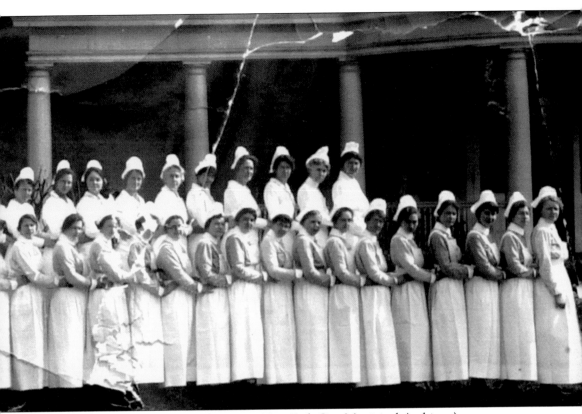

of their residence, Draper Hall. (Courtesy New York City Municipal Archives.)

In this picture, nurses from Metropolitan Hospital enjoy an outing at Lighthouse Park. Nursing students at the various hospitals lived on the island during their three-year course. (Oliver Chapin Collection, Roosevelt Island Historical Society.)

Medical students from Flower Fifth Avenue Hospital studied at Metropolitan Hospital. They lived on the island during their internship and residency. (Oliver Chapin Collection, Roosevelt Island Historical Society.)

Metropolitan Hospital office employees commuted to work by ferryboat from East 78th Street in Manhattan. (Oliver Chapin Collection, Roosevelt Island Historical Society.)

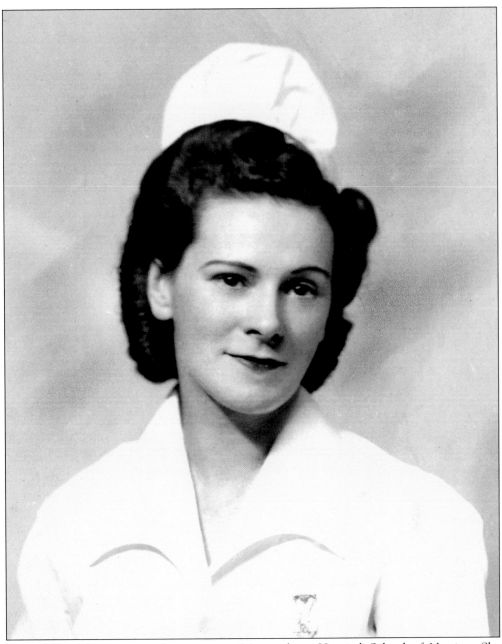

Helen Witcofsky was a student nurse at Metropolitan Hospital School of Nursing. She graduated in 1933. (Courtesy Charles Gelati.)

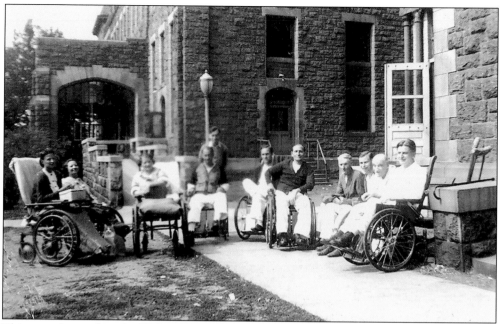

This snapshot, taken by Helen Witcofsky, pictures a group of wheelchair-bound patients enjoying time outside the hospital. (Courtesy Charles Gelati.)

Draper Hall was home for student nurses. It contained dormitories, living rooms, a social room, and classrooms for the students. It was located about 100 yards north of the hospital. (Courtesy New York City Municipal Archives.)

Helen Witcofsky's classmates are sitting at the base of the lighthouse while enjoying the cool breezes. (Courtesy Charles Gelati.)

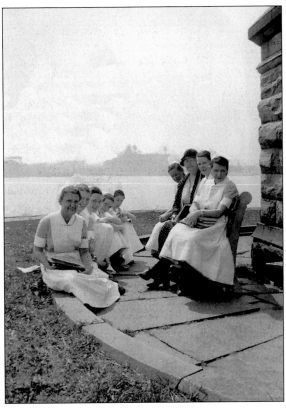

This is another photograph taken by Helen Witcofsky when she was a student nurse at Metropolitan Hospital. Following graduation, she stayed on to work at the hospital for many years. (Courtesy Charles Gelati.)

Here are two more photographs taken by Helen Witcofsky of life on the island as a student and graduate nurse. (Courtesy Charles Gelati.)

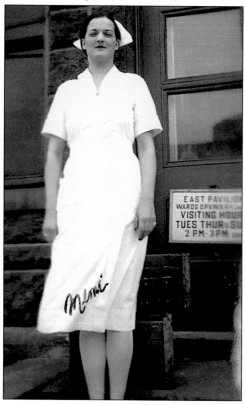

To the right is a young patient in his bed, which has been rolled out on one of the hospital's terraces to provide some degree of comfort on a hot summer day. Below, two nurses pick flowers from the garden. (Courtesy Charles Gelati.)

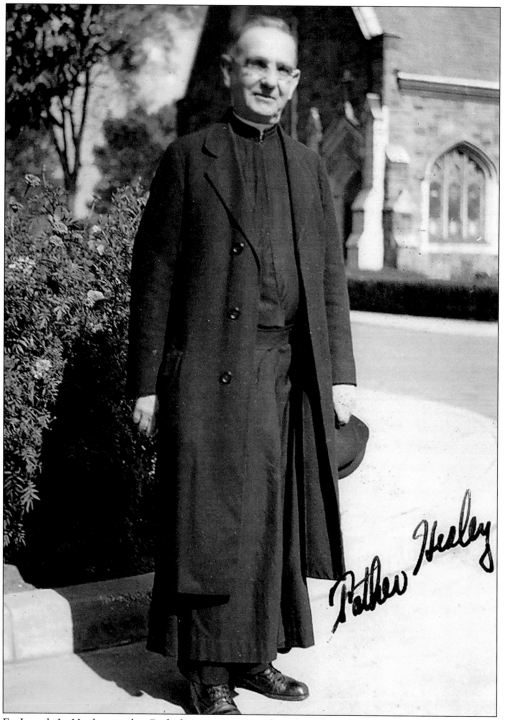

Fr. Joseph L. Healy was the Catholic priest assigned to the Chapel of the Sacred Heart, which was built in 1913 for the Catholic patients at Metropolitan Hospital. Sacred Heart was a separate building because many of the patients were tubercular and could not be integrated into regular services with other patients. (Courtesy Charles Gelati.)

Three

RELIGION ON BLACKWELL'S ISLAND

Religion was an important component in the lives of the residents and staff of the institutions and hospitals. Prior to the late 19th century, most of the institutions had small chapels that the different denominations shared for their ministry. The Chapel of the Good Shepherd was the first formal church built on the island.

The Protestant Episcopal Mission Society opened the chapel in 1889. The Chapel of the Good Shepherd was designed by architect Frederick Clark Withers. He used a variety of building materials with subtle color variations and a relatively simple design to create a beautiful house of worship. Word of the chapel spread, and in the year following its opening, more than 2,000 people from the United States and abroad paid it a visit.

The Protestant inmates of the almshouses were the first to worship in the chapel, which could hold up to 400 people. On the lower level were the island's first library and a robing room for the clergy. Male and female inmates were required to enter separately and sit on their respective sides of the church.

For more than 60 years, Good Shepherd served the Protestant residents and staff. It was closed in 1958 and remained without a shepherd or a flock for 17 years. However, in 1975, the chapel was restored and renovated to serve the Roosevelt Island community as a church for both Catholics and Protestants and also as a community center for the island. The chapel and the tree-lined plaza surrounding this building remain the most used community space on the island.

The Chapel of Our Lady, Consoler of the Afflicted was the first Catholic church, built in 1909 by the Archdiocese of New York to serve the Catholic population who resided in the almshouses. A short distance away stood Council Synagogue. Funded by the National Council of Jewish Women, this synagogue opened in 1927 to provide a house of prayer for the Jewish residents of the almshouses. Completing this religious complex was the Church of the Good Samaritan, which was opened by the Lutheran Inner-Mission Society in 1917. All these structures, except the Chapel of the Good Shepherd, were abandoned and ultimately demolished.

To the north were two other churches to serve the patients at Metropolitan Hospital. One was a small Episcopal church called the Chapel of the Holy Spirit, which was consecrated in 1925. In style, it resembled a quaint English parish church with an attached rectory, a slate roof, and fine stained-glass windows. When Metropolitan Hospital relocated to Manhattan, the chapel was abandoned but never demolished. Across the street from Holy Spirit was a large Roman Catholic church, the Chapel of the Sacred Heart, which faced Queens. It also had an attached rectory and a lovely garden.

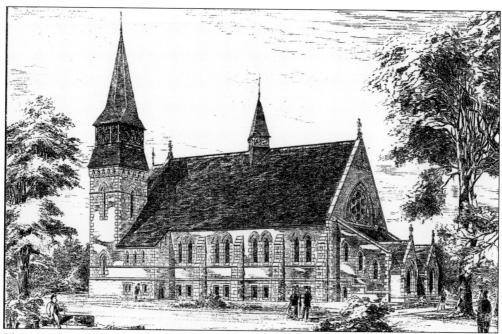

This is a pen-and-ink rendering by Frederick Withers of the Chapel of the Good Shepherd. Every year, in the afternoon on the day of ordination, new priests from the (Episcopal) General Theological Seminary would travel with their bishop to celebrate their first mass in the Chapel of the Good Shepherd. Hundreds of almshouse residents would attend this celebratory service. (Courtesy Archives of the Episcopal Diocese of New York.)

Frederick Clark Withers was the architect of the Chapel of the Good Shepherd. (Oliver Chapin Collection, Roosevelt Island Historical Society.)

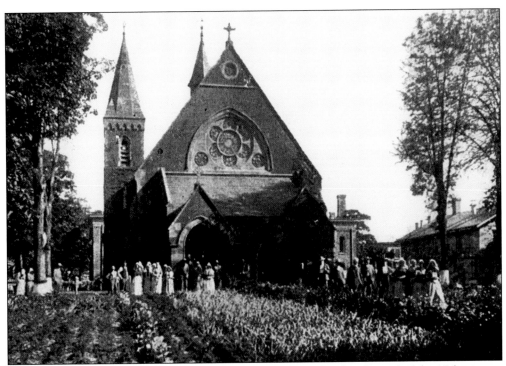

Shown here are two images of the Chapel of the Good Shepherd at the end of the 19th century and the beginning of the 20th century. The outside view shows the gardens tended by the inmates of the almshouse. (Courtesy Archives of the Episcopal Diocese of New York.)

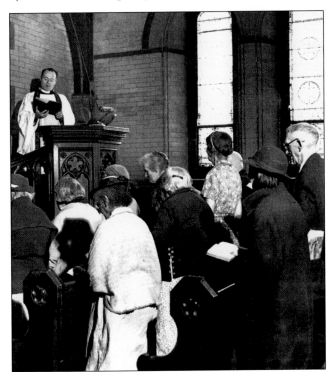

In this photograph, a minister delivers a sermon to the residents of the almshouse in the Chapel of the Good Shepherd. (Courtesy Archives of the Episcopal Diocese of New York.)

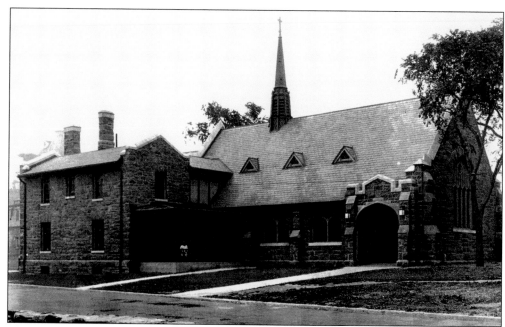

The Chapel of the Holy Spirit was built in 1926 for the Episcopalian patients at Metropolitan Hospital. A beautiful stained-glass rose window above the altar was dedicated to a student nurse who died of illness during her training. It is now used as a chapel by the Redeemed Christian Church of God International. (Courtesy Archives of the Episcopal Diocese of New York.)

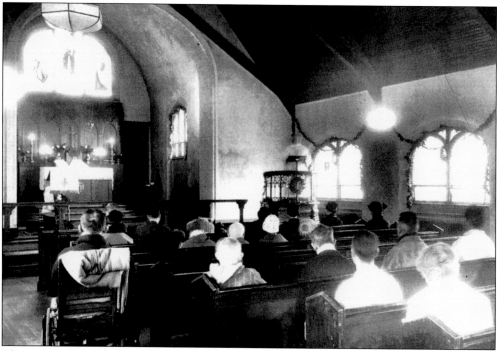

This is an interior view of the Chapel of the Holy Spirit in 1927. (Courtesy Archives of the Episcopal Diocese of New York.)

Shown here is the Chapel of the Sacred Heart. Six community tennis courts now occupy this site. (Oliver Chapin Collection, Roosevelt Island Historical Society.)

The Counsel Synagogue was built in 1926 by the National Council of Jewish Women to serve as a synagogue for the Jewish residents of the almshouses. (Courtesy Bernice Atlas.)

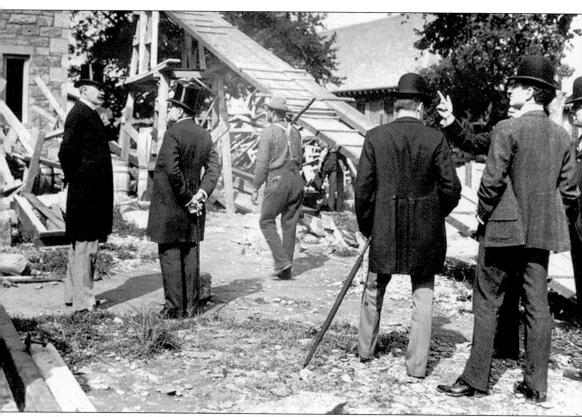

These unidentified VIPs are visiting a construction site on Blackwell's Island. (Courtesy Byron Collection, Museum of the City of New York.)

Four

NINETEENTH-CENTURY ISLAND

At the northern tip of Roosevelt Island, three waterways converge; freshwater flowing down a channel from the Hudson, tidal waters from Long Island Sound, and water from the East River meet. Prior to 1872, huge boulders of granite protruded from the surface of the swirling waters, making navigation at this juncture extremely hazardous. More than 100 ships sank, their crews perishing in the undertows and riptides. This place is called "Hell Gate," a corruption of the Dutch meaning "Hell Channel." The city commissioned the construction of a small lighthouse to throw light on the New York City Lunatic Asylum, thus providing a point of reference for passing ships. Designed by James Renwick in the Gothic style, the 50-foot stone tower was completed in 1872. Local folklore tells the story of a patient named John McCarthy, who feared the British were about to invade Blackwell's Island, and he was allowed to construct a fortress of clay. When the lighthouse was commissioned, the fort was leveled and another patient, Thomas Maxey, actually constructed the lighthouse. A plaque at the base of the tower reads, "This is the work / was done by / John McCarthy / who built the light / house from the bottom to the / top all ye who do pass by may / pray for his soul when he dies."

In the 1870s, the Army Corps of Engineers undertook a huge project. They built caissons, sank them around the outcropping of rocks in the channel, rigged demolitions, and imploded the rock. The channel was also widened and deepened. To this day, however, it remains a difficult place to navigate. The lighthouse continued to operate until the 1940s. In 1975, it was designated as a city landmark. A lovely park was completed in 1980.

In the 1800s, many important discoveries in pathological science took place. Strecker Memorial Laboratory plays an important role in medical history as the first laboratory in the country devoted solely to pathological and bacteriological research. It was constructed in 1892 as a freestanding building near City Hospital, which provided administrative support for the laboratory. Architects Frederick Clarke Withers and Walter Dickson designed the laboratory in the Romanesque Revival style with graceful arches that provided natural light and ventilation. The building originally had two stories. On the first floor were an autopsy room and office. The second floor was used as a laboratory for specimen examination, and the cellar was used as a combination mortuary and storage area. Later, a third floor was added and included a histological examination room, a museum, and a science library. In 1907, the Russell Sage Institute of Pathology first moved to Strecker and later became associated with Rockefeller University. Work continued in the laboratory until the 1950s, when it closed. It remained abandoned until the city found another use for it. The New York City Transit Authority restored the building's exterior. It is now used as a power conversion station for the E and V subway lines.

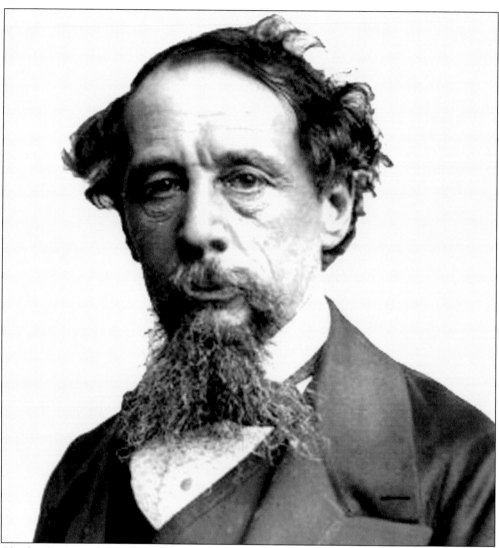

Charles Dickens (1812–1870) is considered the greatest English novelist of the Victorian period. Dickens made two trips to the United States, the first in January 1842. He kept a record of his observations and impressions of this young country that were later published in *American Notes*.

While in New York City, Dickens visited Blackwell's Island. He reached the island in the penitentiary's boat manned by a crew of "prisoners who were dressed in a striped uniform of black and buff, in which they looked like faded tigers." One of the institutions he toured was the asylum. He was impressed by the architecture, especially the elegant staircase in the octagon rotunda; however, he was appalled by the influence of party politics on the administration of this hospital and other public services. "I cannot say that I derive much comfort from the inspection of this charity. The different wards might have been cleaner and better ordered; I saw nothing of that salutary system which had impressed me so favorably elsewhere; and everything had a lounging, listless, madhouse air, which was very painful. The terrible crowd with which these halls and galleries were filled so shocked me, that I abridged my stay within the shortest limits, and declined to see that portion of the building in which the refractory and violent were under closer restraint." (Roosevelt Island Historical Society.)

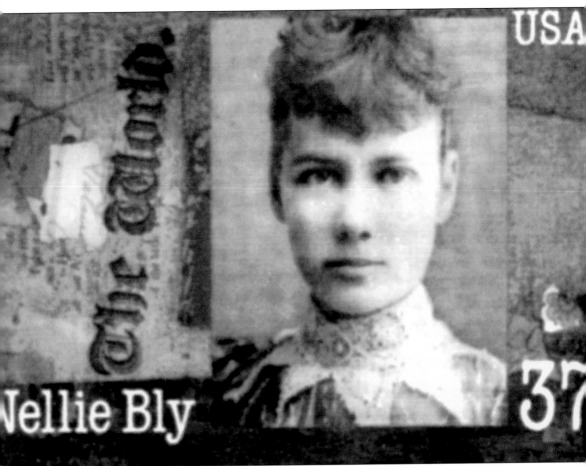

Elizabeth Jane Cochrane (1864–1922) opened the door for women in journalism. For her pen name, she chose Nellie Bly from a Stephen Foster song. A Pennsylvanian, Bly set her sights on New York City and, in 1887, talked Joseph Pulitzer into putting her on the staff of the *New York World.* Her first assignment was to go undercover and write about the conditions at the New York City Lunatic Asylum on Blackwell's Island. She feigned mental illness and, following an examination at Bellevue Hospital, was ferried to the asylum. Bly was appalled by the living conditions and the abusive and indifferent treatment from the staff. She commented, "What, excepting torture, would produce insanity quicker than this treatment?" After Pulitzer succeeded in having Bly released from the hospital, she wrote a series of sensational articles about life in the asylum, which were read across the nation. The New York City officials were embarrassed by the exposé. Following a face-saving investigation, they approved additional funds for the asylum and made changes in administration at the hospital.

World War I broke out in 1914, and Bly became the first female reporter to cover a war from the front lines. Her last major work was a series of articles opposing capital punishment. She died on January 27, 1922, in New York City. (Courtesy U.S. Postal Service.)

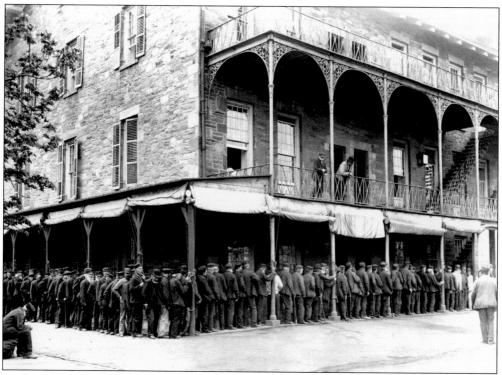

In this photograph, male residents of the New York City Almshouse line up outside the building. (Courtesy Byron Collection, Museum of the City of New York.)

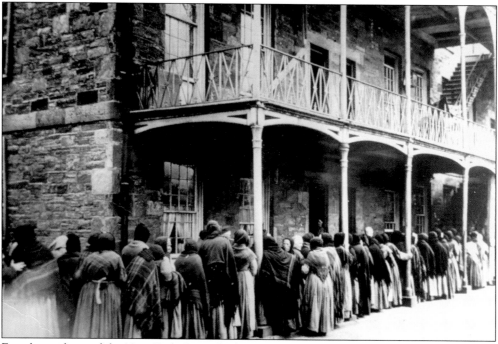

Female residents of the New York City Almshouse wait outside the building for their meals to be served. (Oliver Chapin Collection, Roosevelt Island Historical Society.)

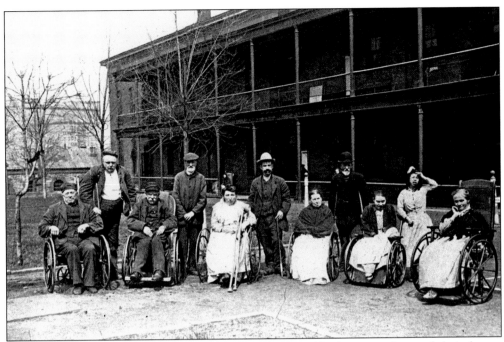

Pictured are disabled residents of the New York City Almshouse in front of their home. (Copyright Carol Kitman, Oliver Chapin Collection, Roosevelt Island Historical Society.)

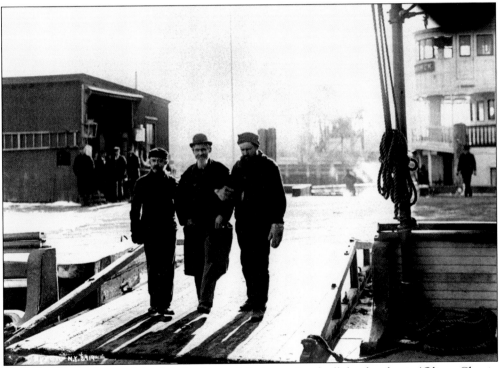

An elderly man destined for the almshouse is being assisted off the ferryboat. (Oliver Chapin Collection, Roosevelt Island Historical Society.)

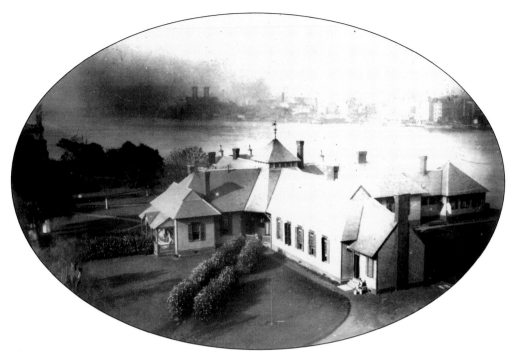

The Maternity Pavilion was one of the first of its kind in the country to be constructed as separate unit from the regular hospital. Shown in 1884, it adjoined City Hospital. (Courtesy Roosevelt Island Operating Corporation.)

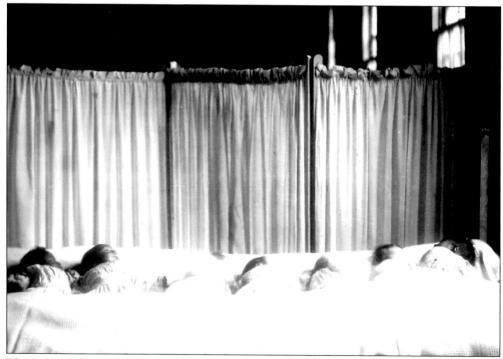

This *c.* 1900 photograph shows infants sleeping in the Maternity Pavilion. (Courtesy Roosevelt Island Operating Corporation.)

THE CITY OF NEW YORK. P 115636 STATE OF NEW YORK
DEPARTMENT OF HEALTH — CHANGES APPROVED BY COMM'R OF HEALTH

CERTIFICATE AND RECORD OF BIRTH

OF

Name of Child HELEN Mary Vlissaroulis 543

Sex Fem.	Color or Race white	Twin, triplet or other Number, in order of birth	Mother's Marriage Name	Catherine Vlissaroulis
Date of Birth Sept 1st 1933		Hour 6:25 P.M.	Mother's Name Before Marriage	Catherine Constantine
Place of Birth Street, No. and Borough City Hospital W. I.			Mother's Residence	404 W 51 st
Father's Name PARASEOS Parastros Vlissaroulis			Mother's Birthplace	Greece
Father's Residence 404 W 51st			Mother's Age 23 Years	Color or Race white
Father's Birthplace Greece			Mother's Occupation Housewife	Nature of Industry
Father's Age 45 Years	Color or Race white		Number of Children Born to this Mother including Present Birth	One
Father's Occupation Restaurant worker	Nature of Industry		Number of Children of this Mother Now Living	One

I, the undersigned, hereby certify that I attended professionally at the above birth and am personally cognizant thereof, and that all the facts stated in this certificate and report of birth are true to the best of my knowledge, information and belief.

Signature PHYSICIAN

FILED SEP 9 – 1933

Date of Report, SEP 5 '333 19..

Residence

MANHATTAN

Shown here is a birth certificate of a woman born on Welfare Island. The place of birth is listed as "WI," which stands for Welfare Island. The island is still considered, for political purposes, a part of the borough of Manhattan. (Courtesy Katherine Vithlani.)

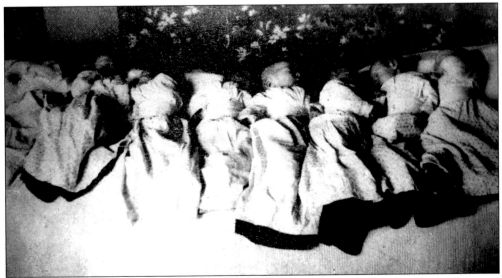

Dr. Henry J. Garrigues introduced the practice of antiseptic midwifery at Charity Hospital (later known as City Hospital). As a result, the infant mortality rate was reduced by more than 90 percent, and his methods were soon adopted throughout the country. Pictured are healthy babies born at the hospital in 1884. (Courtesy Roosevelt Island Operating Corporation.)

This 1903 drawing shows the floor plan for an addition to the Smallpox Hospital. Two wings were added to the Smallpox Hospital to provide accommodations for the nursing school. Both wings were named after influential women who were instrumental in establishing nursing as a profession. One wing was named Jones Hall as a tribute to Mrs. Cadwalader Jones, and the other, Rice Hall, in honor of Mrs. William Rice. (Oliver Chapin Collection, Roosevelt Island Historical Society.)

This is an architectural rendering of Strecker Memorial Laboratory. On the exterior of the building, gray stone and brick was used, and orange brick tile lined the walls within the building. The effect was not only pleasing to the eye but also practical for the building's purpose. (Oliver Chapin Collection, Roosevelt Island Historical Society.)

Shown here is an architectural rendering of Good Samaritan Lutheran Church, which opened in 1917 to serve the large German immigrant population on Blackwell's Island. All the houses of worship were financially supported and staffed by missions of the various faiths. (Oliver Chapin Collection, Roosevelt Island Historical Society.)

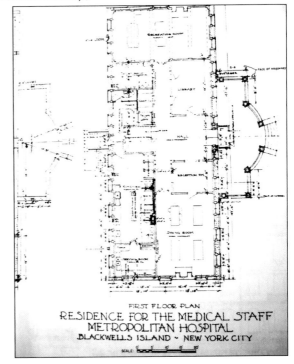

Pictured is an architectural rendering for the medical staff residence. Large, comfortable quarters for nurses and doctors were built on the island with such amenities as tennis courts, libraries, and recreation rooms. (Oliver Chapin Collection, Roosevelt Island Historical Society.)

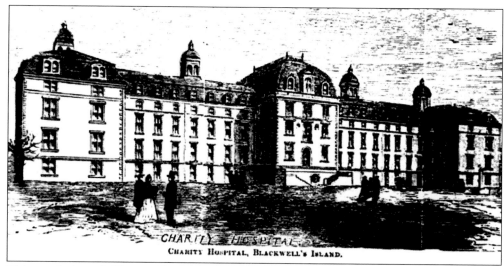

CHARITY HOSPITAL, BLACKWELL'S ISLAND.

This rendering of Charity Hospital appeared in *Harper's Weekly.* Charity Hospital, later renamed City Hospital, was acclaimed for its grand copper mansard roof, an architectural style very much in vogue during that period. (Courtesy Harper's Weekly Magazine.)

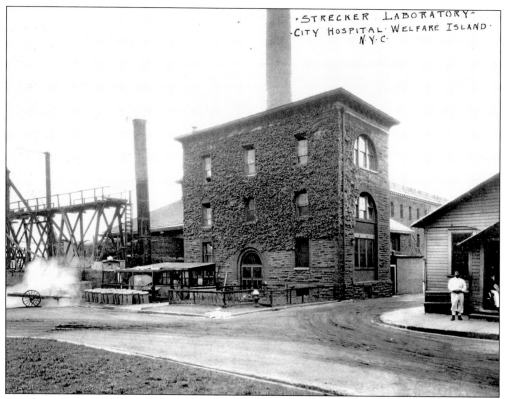

Strecker Memorial Laboratory of City Hospital was built in 1909 according to a design by Withers and Dickson. It was the nation's first center for studying pathology. (Roosevelt Island Historical Society.)

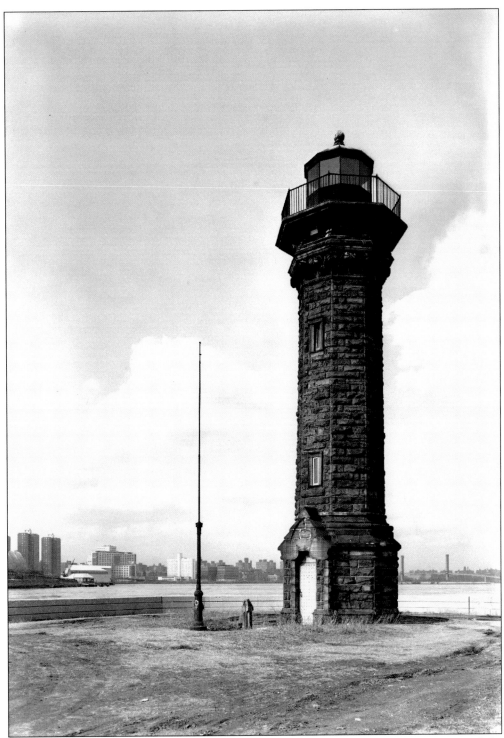

Shown here is the Blackwell's Island Lighthouse. The antenna on the left was part of the meteorological station at the northern tip of the island. (Courtesy Historic American Buildings Survey, Library of Congress.)

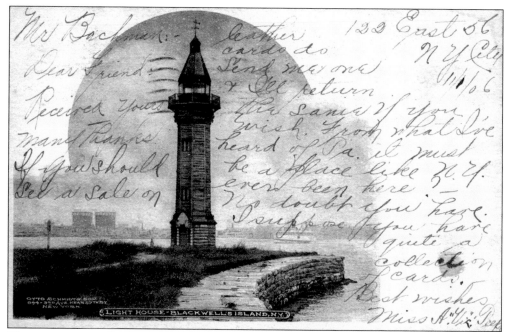

This is a postcard view of the lighthouse at the north end of the island. (Roosevelt Island Historical Society.)

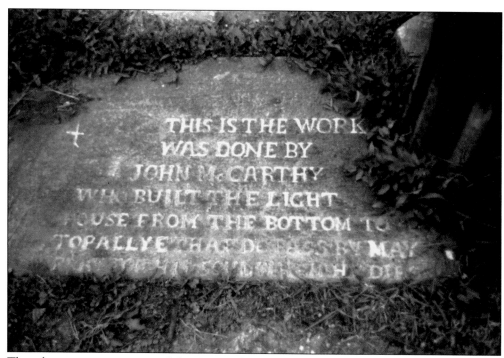

The plaque commemorating John McCarthy was located at the base of the lighthouse. (Courtesy Historic American Buildings Survey, Library of Congress.)

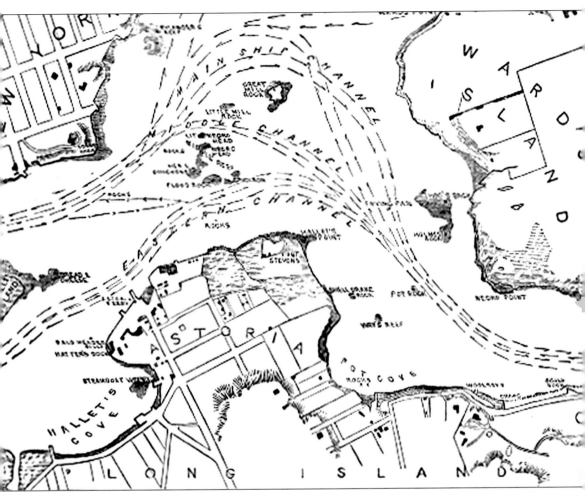

This map shows the Hell Gate area prior to the demolition of the granite rocks that proved to be such a hazard to navigation. The Army Corps of Engineers set off a series of blasts of a magnitude that was not equaled until World War II with the destruction of Hiroshima. (Courtesy *Making of America: Cornell University*.)

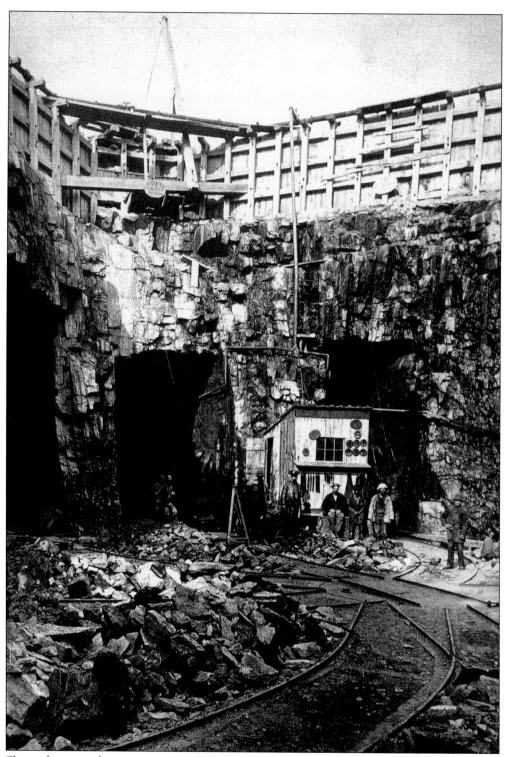

Shown here are the excavations at Hell Gate in preparation for the explosion of the rocks.
(Courtesy *Making of America: Cornell University.*)

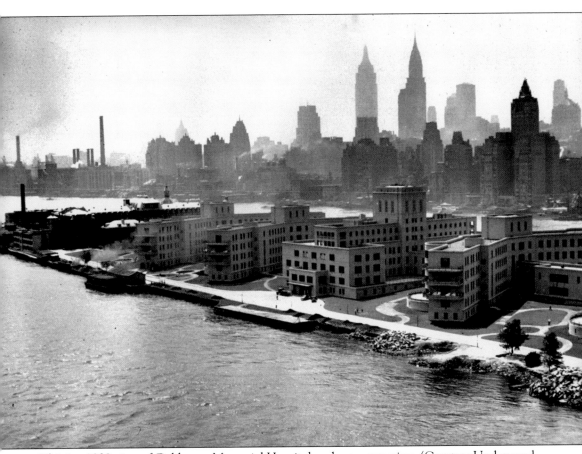

This is a 1939 view of Goldwater Memorial Hospital under construction. (Courtesy Underwood and Underwood.)

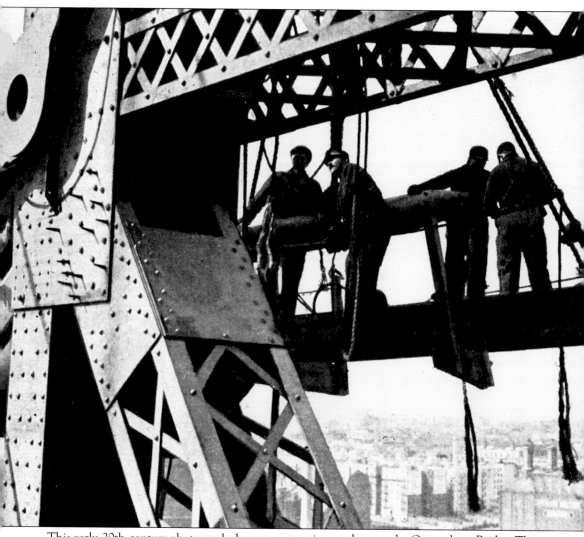

This early-20th-century photograph shows construction workers on the Queensboro Bridge. They are standing on an I-beam to insert a huge pin into the structure. (Courtesy *Harper's Weekly.*)

Five

THE QUEENSBORO BRIDGE

As early as 1838, businessmen and politicians were interested in constructing a bridge to span the East River from Manhattan to Queens. In 1857, a group of powerful men with business and real estate interests organized to build such a bridge. The chief backer was Austin Corbin, a millionaire who had a majority interest in the Long Island Rail Road. He wanted to connect the Harlem Line in Manhattan with the Long Island Rail Road and run a spur south to the Brooklyn Navy Yard. Other important backers included William Steinway, whose plant in Astoria, Queens, manufactured pianos, and Dr. Thomas Rainey, owner of a steamship company. They proposed a two-mile-long suspension bridge that would run from East 77th Street to Queens. In 1867, they received a state charter for the New York and Long Island Bridge Company. Delays, political wrangling, and other problems plagued the company, and following the construction of one pier, it went bankrupt in 1893.

Interest in the bridge did not die. Gustof Lindenthal, in collaboration with Leffert L. Buck and Henry Hornboster, drew up plans for a twin cantilever bridge. This design took advantage of the position of Blackwell's Island in the East River; two of the support piers would stand on the island. Again, in spite of pressure from the city and business leaders, delays occurred: there was a strike at the Pennsylvania Steel Company, which held the contract to manufacture the steel parts for the bridge; labor unions opposed the hiring of nonunion workers; some engineers questioned the safety of the design; and a section of the unfinished bridge blew down during a violent windstorm.

The bridge finally opened in 1909 with grand ceremony, including a spectacular two-hour fireworks display. For a brief time, it was called the Blackwell Bridge, but the name soon changed to the Queensboro Bridge. Its opening was a defining moment for the borough of Queens. Its rural landscape of farms and small towns was forever altered. Industry immediately began to build factories on the Queens side of the bridge. The development of housing soon followed, and small towns were swallowed up in the expansion of the city, which flowed into Long Island with the opening of the Brooklyn and Queensboro Bridges.

The Queensboro Bridge is constructed entirely of a mass of interfacing structural steelwork that creates repeating patterns across its length. Four 459-foot towers built on stone piers support the massive weight of the bridge, and tasteful architectural adornments in steel, stone, and tile enhance the bridge and its approaches. The bridge is a visual symbol of the strength, grace, and energy of the city that built it. The multispan bridge has two levels. Two railway tracks were installed in 1917 to carry subway cars from Manhattan to Astoria and Corona. Originally, six lanes were provided for vehicular traffic—four in the center of the lower level and two on the upper. On the outer lanes of the lower level were tracks for a trolley car service, which ran from one end of the bridge to the other. The trolleys made two stops on the bridge—one above Vernon Avenue in Long Island City and the other above Blackwell's Island. Passengers reached the street by elevator. The elevator to Blackwell's Island was placed in a storehouse, which stood on land now occupied by the Roosevelt Island Tramway station. The storehouse was nicknamed

the "upside-down building" because the reception area and lobby were located on the top floor of the structure. Ambulances carrying patients were driven from the bridge into the elevator and upon arrival at street level, the ambulance continued on to the appropriate hospital. All those who lived and worked on the island welcomed having this much improved method of access to the island. In 1921, the city decided to change the island's name to Welfare Island to reflect advances made in management and delivery of services at the institutions.

The railway tracks were removed in 1942, when tunnels dug under the East River for rail traffic were completed. Subway lines now access Queens through tunnels dug under the East River. The trolley car service ceased operations with the opening of the Welfare Island Bridge in 1955; the unused elevators were torn down in the 1970s. During the most recent reconstruction, the lower level was reconfigured to four wide lanes with a median barrier in the center and pathways for pedestrians and bicyclists.

For many years, the city often deferred routine maintenance. Weather, exhaust from vehicles, and spotty maintenance weakened the structure. In 1957, the elegant towers that once held flying flags had to be removed because they were dangerously corroded. Subsequent inspections detected other structural damages that prompted the New York City Department of Transportation to embark on a 14-year-long reconstruction project. Eventually, the bridge was repaired as well as the Guastavino-tiled marketplace in the Manhattan approach, which is now home to elegant shops and restaurants. The bridge cost $20 million to build and $180 million to repair and reconstruct. It is one of the most heavily trafficked bridges in the world. On an average day, it carries 200,000 vehicles. At 94 years old, its main cantilever span from Manhattan to Roosevelt Island remains the 12th longest ever constructed.

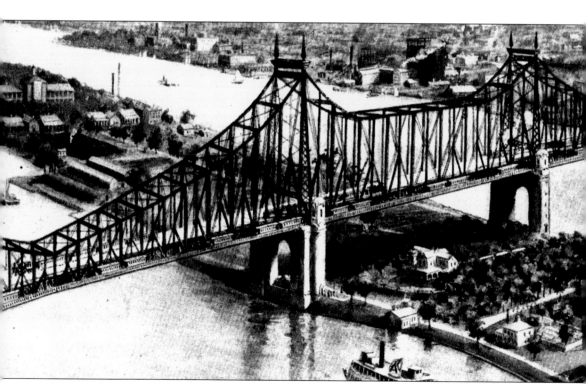

A view of Blackwell's Island shows the completed bridge. From south to north are Smallpox Hospital, Maternity Hospital, City Hospital, the Blackwell's Island Penitentiary, and the

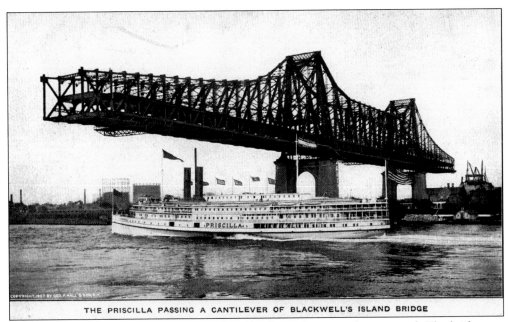

THE PRISCILLA PASSING A CANTILEVER OF BLACKWELL'S ISLAND BRIDGE

A boat passing under the partially completed bridge is shown in this postcard. The bridge was built in three sections and cantilevered from Queens, Blackwell's Island, and Manhattan. Later, all three sections were connected. (Roosevelt Island Historical Society.)

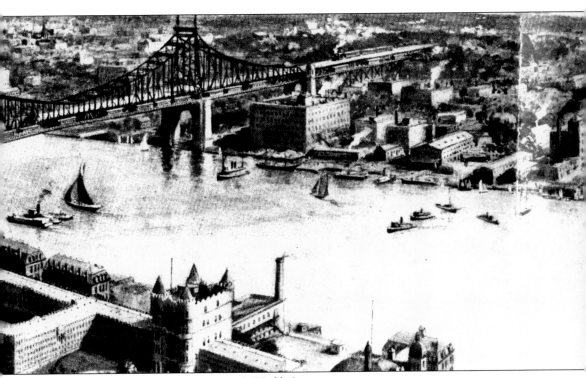

Queensboro Bridge. (Courtesy *Harper's Weekly*.)

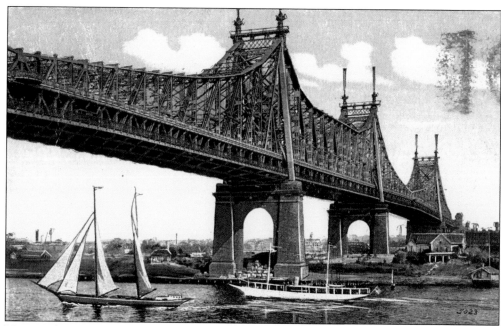

Note in this postcard of the Queensboro Bridge the imposing house just south of the bridge. This was the home of the penitentiary's warden, who lived in luxurious style. (Roosevelt Island Historical Society.)

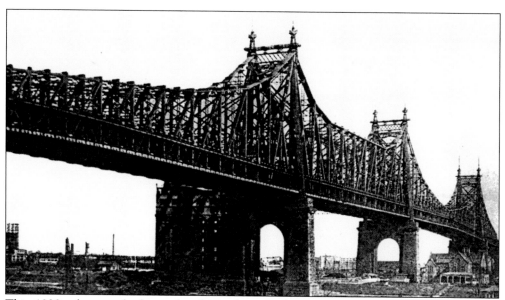

This 1920s photograph shows the Queensboro Bridge and the storehouse built next to a supporting tower. This structure contained an elevator large enough to accommodate motor vehicles and foot passengers traveling to and from the bridge. It was also used as a distribution center for stored supplies. (Roosevelt Island Historical Society.)

These 1920s photographs show bustling Manhattan with a view of the island in the background. Above, people are sculling, and the Blackwell's Island Penitentiary can be seen in the background. Below, people are swimming in the East River. Note the tugboat pulling a barge filled with garbage. (Oliver Chapin Collection, Roosevelt Island Historical Society.)

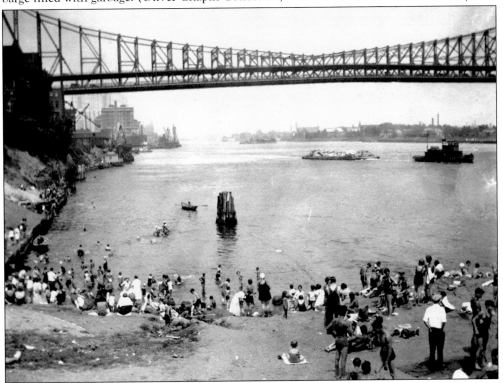

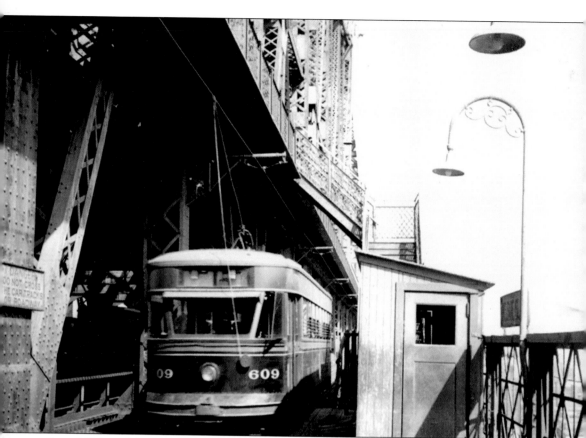

From 1914 until 1955, trolley service operated from Queens to Manhattan over the Queensboro Bridge. At mid-span, people traveling to the Welfare Island would take an elevator down to ground level from the bridge. (Roosevelt Island Historical Society.)

Shown here is a trolley at the Queens side of the Queensboro Bridge. Before the Welfare Island Bridge was built, this trolley would drop passengers for Welfare Island off at the mid-span storehouse, where they would take an elevator to the island. Trolley service ceased operations in 1955. (Roosevelt Island Historical Society.)

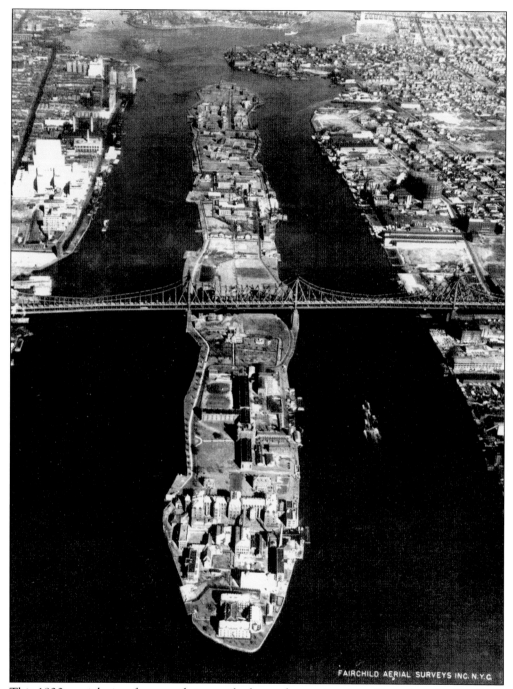

This 1920s aerial view from south to north shows the penitentiary. Note that the Smallpox Hospital stands at the water's edge. Now, eight acres of landfill have elongated the island. (Courtesy Fairchild Aerial Surveys, New York City.)

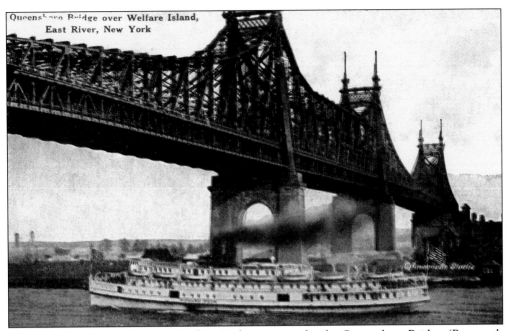

This postcard shows the steamer *William Peck* passing under the Queensboro Bridge. (Roosevelt Island Historical Society.)

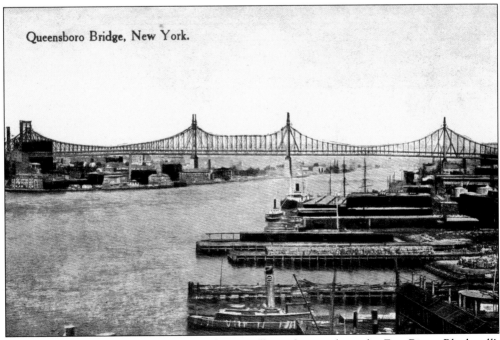

This view looking north from Queens shows walks and piers along the East River. Blackwell's Island appears in the background. (Courtesy Success Postcard Company.)

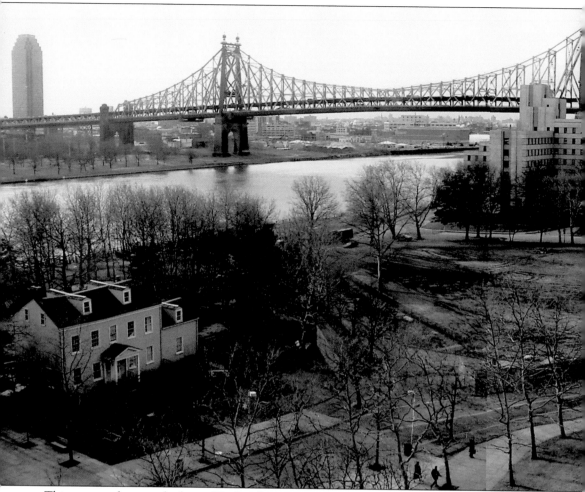

This recent photograph shows Blackwell House in the foreground and the Central Nurses Residence in the background. The latter building was demolished in 2001 to make way for the

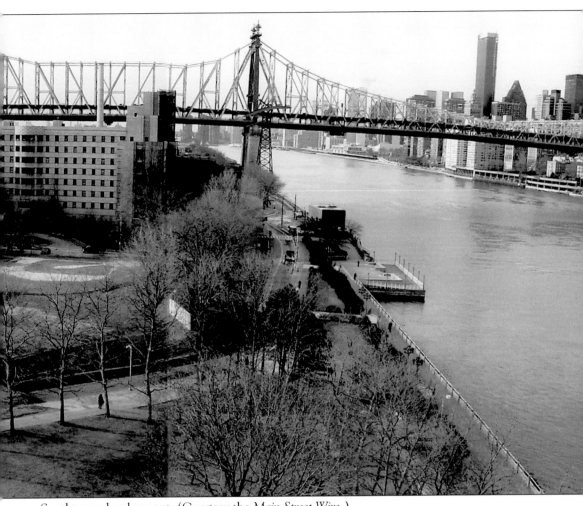

Southtown development. (Courtesy the *Main Street Wire*.)

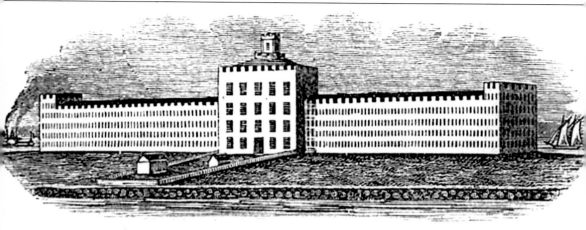

View of the Penitentiary on Blackwell's island.

The Blackwell's Island Penitentiary is shown here in 1838. (Roosevelt Island Historical Society.)

Six

THE PENITENTIARY

In 1796, New York State built its first penitentiary in Greenwich Village, only a mile and a half north of city hall. The state prison was popularly known as "Newgate" after Great Britain's prison of the same name. Although they shared a label, the American Newgate was referred to as a penitentiary rather than a prison. This reflected a difference in concepts as to the purpose of incarceration. Social reformers, mainly members of the Quaker Society of Friends, led the movement to make the criminal justice system more humane, believing that each person had an "inner light" and could be redeemed if they recognized their sins and did penitence. The Greenwich Village Newgate closed after 27 years, and the prisoners moved upstate to the newly constructed Sing Sing. The city of New York had separate city institutions, including a penitentiary at Bellevue on the shores of the East River. They planned to buy Newgate but instead purchased Blackwell's Island as a more promising site for the facility. This location moved the penitentiary and charitable institutions a comfortable distance from Manhattan.

Prisoners from Bellevue were immediately sent to the island to grade the land, build a seawall around the island, and start construction on the new penitentiary. It was a very large structure, 600 feet long and four stories high. Shaped as an L, it consisted of three structures, a short wing on the north side joined at a right angle to the administration building and the longer cellblock wing. The penitentiary faced Manhattan parallel to the East River on the site now occupied by the Goldwater Campus of Coler-Goldwater Speciality Hospital and Nursing Facility. The first institution built on Blackwell's Island, it was constructed of granite blocks from a nearby quarry and, in appearance, resembled an austere medieval castle. Designed with 800 cells for the prisoners, it was often overcrowded. All prisoners were required to work. The stronger labored at the quarry or constructed additional institutions on Blackwell's Island, as well as other islands. Other male prisoners worked in the various penitentiary workshops, and the incarcerated women cooked, sewed, cleaned, and acted as nurses to the other convicts. It was truly an appropriate place to do penitence.

In 1852, the Blackwell's Island Workhouse was built to replace the 100-year-old workhouse located at the Bellevue site. This facility functioned as a house of correction for those convicted of minor offenses. Known as "drunks and disorderlies," these convicts served short sentences and were assigned duties similar to those of the penitentiary inmates.

In 1894, W.L. Strong was elected mayor of New York City with support from social reformers. Until that time, one huge agency oversaw all charitable institutions and prisons. Mayor Strong believed that forming separate agencies to administer the charitable and correctional institutions would improve management. In a message to the Common Council, he noted that there were three times the number of people in the workhouses, almshouses, hospitals, and prison than were originally planned for: "The condition of our City Prisons, to speak broadly, is execrable, and the accommodations in the Almshouse and Workhouse insufficient, inadequate and incomprehensible, while overcrowding is a startling characteristic of the penitentiary." His restructuring marginally benefited the charitable institutions, but it had little impact on the

Blackwell's Island Penitentiary. In 1921, as part of its reform effort, the city council decided to improve the island's image by changing the name to Welfare Island. Reports of inmate overcrowding, drug dealing, and favoritism continued to fill the popular press but were not addressed by the city. In 1933, reformer Fiorello LaGuardia was elected mayor. One his first acts was to appoint Austin H. MacCormick as correction commissioner. In January 1934, MacCormick and his men raided the penitentiary on Welfare Island. The place was run by two highly organized gangs, each with its own boss. These racketeers lived comfortably, enjoying many amenities while the majority of prisoners existed in miserable conditions. The bosses and 66 gang members were put into solitary confinement, and the warden of the penitentiary was suspended from his duties. In a short time, all remaining inmates were removed to the recently completed prison on Rikers Island. Mayor LaGuardia, considered by some to be the greatest of New York City's mayors, had clearly demonstrated his intentions to clean up the city. In 1936, the Blackwell's Island Penitentiary was razed. Welfare Island stood waiting for its future to be decided.

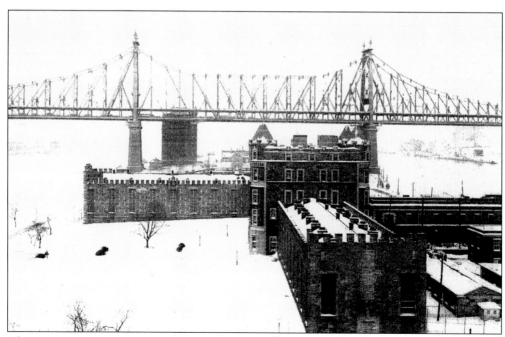

Above is a snowy winter view of the penitentiary. (Roosevelt Island Historical Society.)

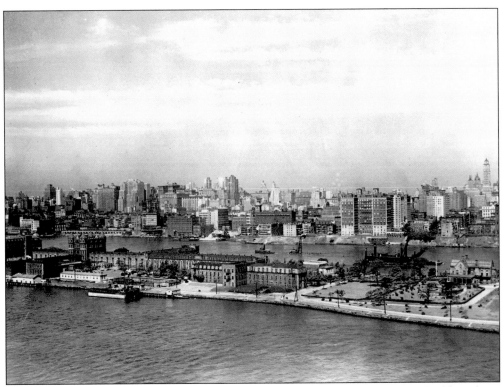

In this 1920s view of Welfare Island, neither the Chrysler nor the Empire State Buildings have been constructed. (Courtesy Underwood and Underwood.)

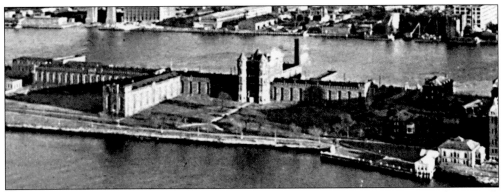

Here is another view showing the vastness of the penitentiary structure. (Roosevelt Island Historical Society.)

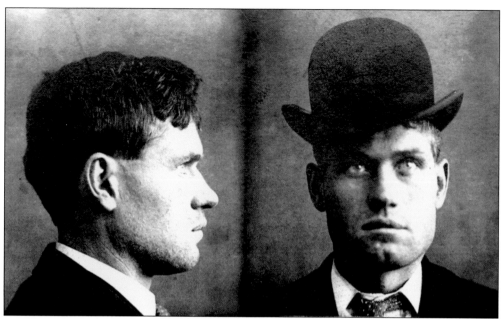

Harry Wright, age 32, was convicted of burglary and served time at the island's penitentiary. The Bertillon measurements included both a description of the prisoner's physical characteristics and the nature of their crime. Wright had hazel eyes and brown hair. He also had a number of interesting tattoos on his upper body and right arm, including an impressive eagle that covered his shoulder. (Oliver Chapin Collection, Roosevelt Island Historical Society.)

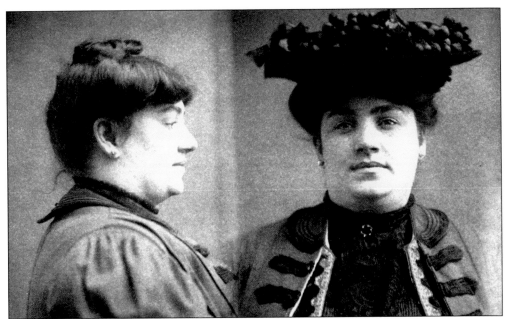

Two views of each prisoner were taken for placement on the front of the Bertillon card—one with a hat and one without. Information on the back of this card identifies this prisoner as Annie Kelly, a 25-year-old woman born in this country who had been convicted of robbery and sentenced by Judge Mahoney. She had brown hair and blue eyes and was of medium stature. She also had a scar under her chin. (Oliver Chapin Collection, Roosevelt Island Historical Society.)

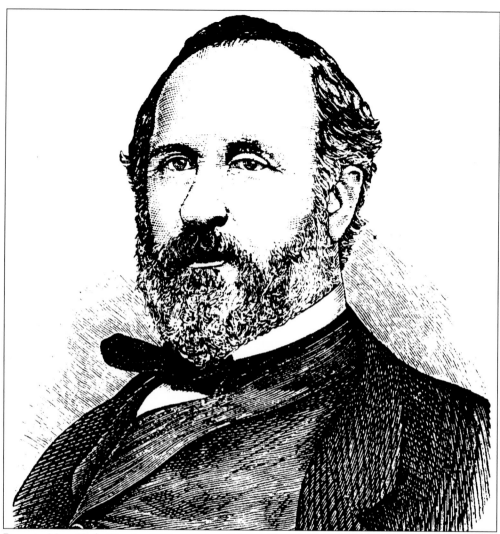

Born in New York City in 1823, William Marcy Tweed was a huge man at six feet tall and 300 pounds. The political career of one of New York City's most corrupt historical figures began in 1851, when he was first elected to public office. The charismatic Tweed used his considerable skills as a politician and rose to high office. By 1868, all branches of the city and state governments came under his control. In 1870, he paid a large bribe to pass a new city charter through Albany, creating a board of audit of only three people. The Tweed ring then proceeded to sack the city treasury while the infrastructure of the city fell apart. Slowly, the voices of reform began to be heard. In 1869, *Harper's Weekly* published a series of cartoons by Thomas Nast denigrating Tweed, and the *New York Times* published a series of stories detailing the embezzlement. These revelations outraged the citizenry. In 1871, a meeting of the city's leading business and professional men was held at Cooper Union. A taxpayer's suit was filed against Tweed for forgery and larceny. He was tried and sentenced to one year at the Blackwell's Island Penitentiary. Although he lived in comfort at the facility, his world was falling apart. Upon his release, Tweed was immediately rearrested on civil charges. Again he was convicted and imprisoned, but he escaped to Cuba, then Spain. Identified by a cartoon drawn by Nast, the Spanish government extradited Tweed to New York, and he was imprisoned where he died on April 12, 1878. (Roosevelt Island Historical Society.)

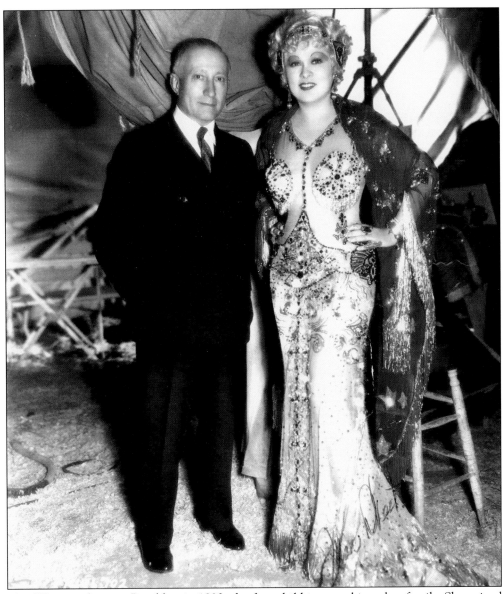

Mae West was born in Brooklyn in 1893, the first child in a working-class family. She gained national notoriety in 1926, when she appeared in a Broadway play called *Sex*, which she co-authored and produced. Her resulting arrest and conviction was widely publicized. West was sentenced to serve a 10-day sentence at the workhouse on Welfare Island, but she was released three days early for good behavior. At the workhouse, West was given a private cell and was assigned to sweep floors. There was gossip that every afternoon the warden drove West around the island in his touring car. On at least one occasion, he took her to meet his mother. Her only complaint was the prison-issued uniform, a heavy blue dress and white stockings. She wrote a poem about the scratchy underwear and dedicated it to the warden. The Mae West Memorial Prison Library was established by West with monies she received for a magazine article about her incarceration. After a long and successful career, she died on November 22, 1980, in Los Angeles, California. She is pictured here with her producer, Aldoph Zukor. (Oliver Chapin Collection, Roosevelt Island Historical Society.)

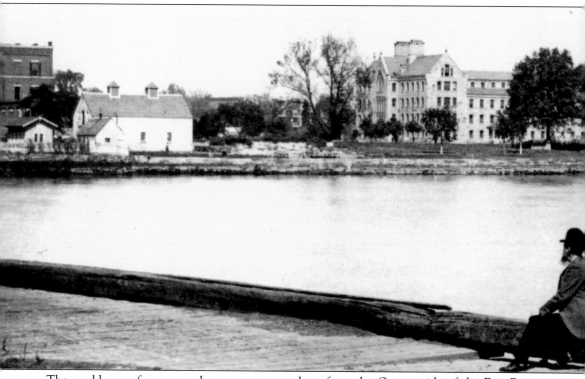

The workhouses for men and women are seen here from the Queens side of the East River. It was common for the same people to return to the workhouse just days after their release.

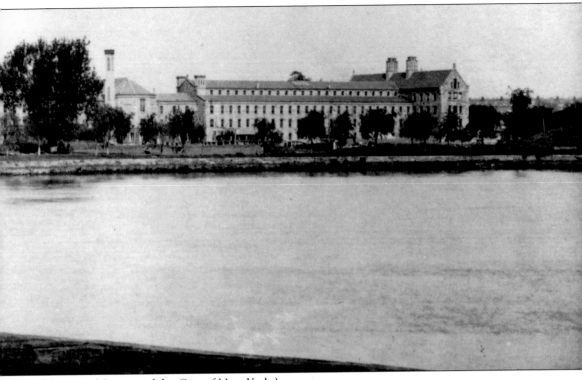

(Courtesy Museum of the City of New York.)

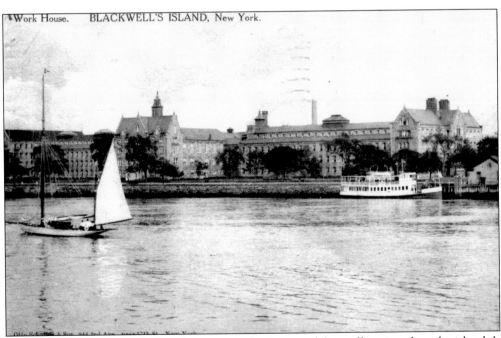

Many female inmates worked as domestics in the homes of the staff stationed on the island. It was not uncommon for them, following their release, to get themselves rearrested and within days be back at their old jobs. (Roosevelt Island Historical Society.)

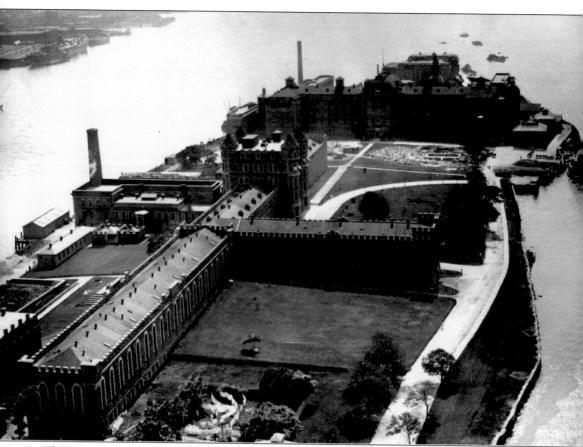

This 1907 aerial view taken from the unfinished Queensboro Bridge shows, from bottom to top, the Blackwell's Island Penitentiary, City Hospital, Smallpox Hospital, and two ferryboats in the river transporting patients from Bellevue Hospital to City Hospital. (Copyright George G. Bain.)

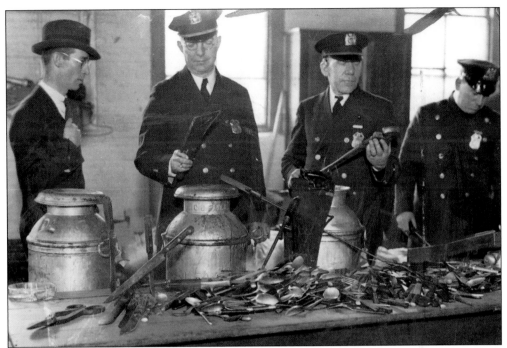

In 1934, reform-minded Mayor Fiorello La Guardia had his newly appointed commissioner of correction, Austin MacCormick, raid the notorious Blackwell's Island Penitentiary. This photograph shows weapons that were confiscated from the prisoners. (Courtesy Underwood and Underwood.)

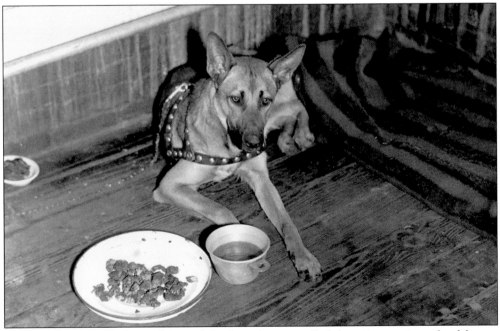

Screw-Hater, the pet of one of the mob leaders who controlled the prison, enjoys a beef dinner. Ordinary prisoners never had such a good meal. (Courtesy Underwood and Underwood.)

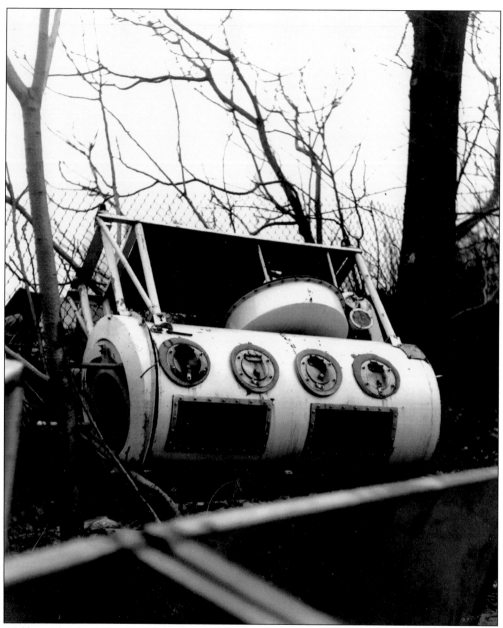

Welfare Island was home to the New York Chronic Disease Hospital (later, the Goldwater Memorial Hospital, which specializes in long-term care). Thousands of polio patients were treated at this facility. At the time, patients who lost the ability to breathe on their own were confined in iron lung machines such as the one pictured here. (Copyright Anne Kayser.)

Seven

ABANDONMENT

The population of Welfare Island began to decline at the end of the 19th century. Many of the institution's physical plants had become antiquated. In the late 1800s, the city entertained a proposal to raze the buildings and create a lavish public park. No action was taken at the time, but in 1936, parks commissioner Robert Moses again raised the idea. However, Sigmund S. Goldwater, the commissioner of hospitals, supported locating a hospital park consisting of seven modern hospitals and support facilities for the chronically ill. Goldwater won the battle, and in 1939, a fine nurses' residence was completed. A year later, Chronic Disease Hospital, which was renamed in 1942 for the late Sigmund S. Goldwater, opened its doors. Goldwater Hospital was built on the site of the demolished Blackwell's Island Penitentiary. It covers a 10-acre site and consists of seven connected chevron-shaped buildings that face Manhattan.

All city construction came to a halt in 1942 following the declaration of war. By the time World War II was over, the city had other priorities, and only one additional facility for the chronically ill was built. Bird S. Coler Hospital was opened in 1952. Occupying a 14-acre site at the northern tip of the island, the facility consisted of three joined buildings. Coler and Goldwater merged in 1996, and the hospital is now known as Coler-Goldwater Specialty Hospital and Nursing Facility. It is part of the New York City Health and Hospitals Corporation.

In 1955, City Hospital at the southern end of the island relocated in Elmhurst, Queens, and is now known as Elmhurst General Hospital. Metropolitan Hospital moved to the Upper East Side, and the New York City Home, formerly known as the New York City Almshouse, began the process of moving its residents to residential facilities on Staten Island or to Bird S. Coler Hospital.

As the institutions ceased operations, the churches lost their parishioners, and they too closed. Blackwell House lost its tenants and began to decay. The Smallpox Hospital and, later, the New York School of Nursing closed and was stripped of its decorative fittings by vandals. The roof collapsed, and only the facade with gothic frames remained standing of the once elegant building. Much later, the Nurses Residence at the base of Main Street was shuttered and all its 600 rooms vacated. By 1975, only two city hospitals remained in operation on Roosevelt Island: Bird S. Coler Hospital and Goldwater Memorial Hospital.

The New York City Fire Department began to use the island as a training site because of the abundance of empty structures, which had been used as storage houses, workshops, and other purposes for the institutions.

Welfare Island became a haunted, desolate landscape full of wonderful abandoned buildings and the memories of those who were tied to the buildings' history. Still, it remained a part of restless New York City, and the quiet of the place was soon whisked away by 20th-century development.

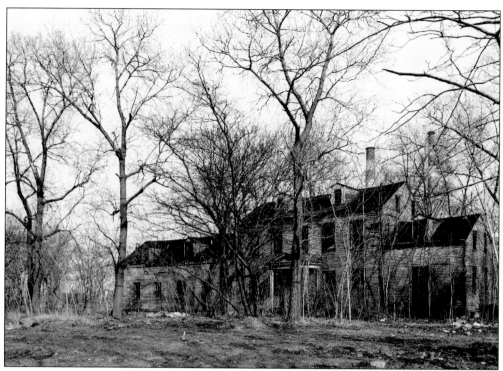

Blackwell House was abandoned in 1955, when most of the medical institutions closed. These exterior photographs show the deterioration of this once lovely farmhouse. (Courtesy Historic American Buildings Survey, Library of Congress.)

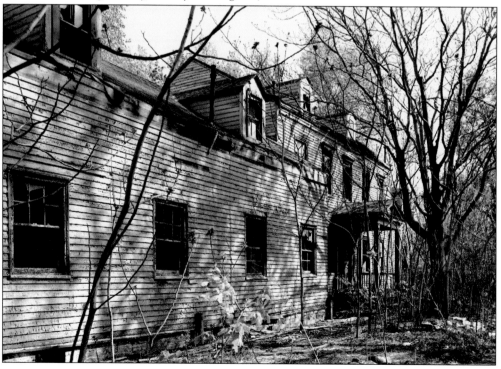

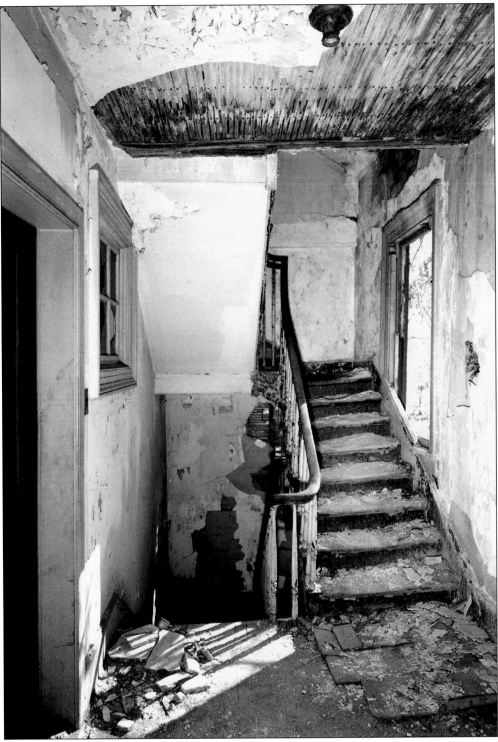

Shown here is the interior of the abandoned Blackwell House. (Courtesy Historic American Buildings Survey, Library of Congress.)

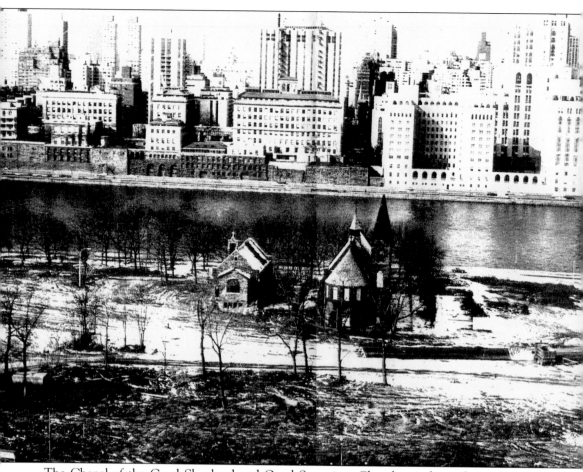

The Chapel of the Good Shepherd and Good Samaritan Church are shown here after the demolition of all buildings of the New York City Almshouse. Later, Good Samaritan Church (left) was demolished. (Courtesy Historic American Buildings Survey, Library of Congress.)

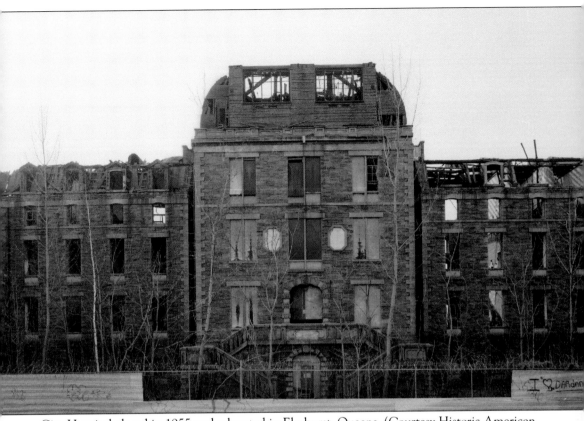

City Hospital closed in 1955 and relocated in Elmhurst, Queens. (Courtesy Historic American Buildings Survey, Library of Congress.)

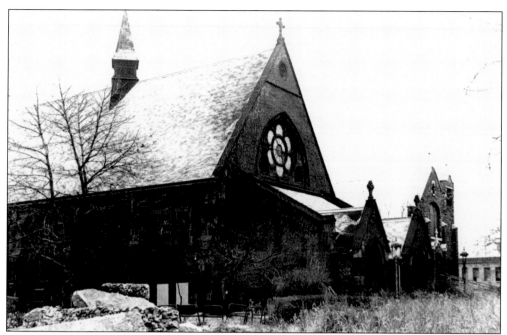

The Chapel of the Good Shepherd is shown here with Good Samaritan Church in the background. This photograph was taken in 1966, when both houses of worship had been standing empty for 10 years. (Copyright Anne Kayser.)

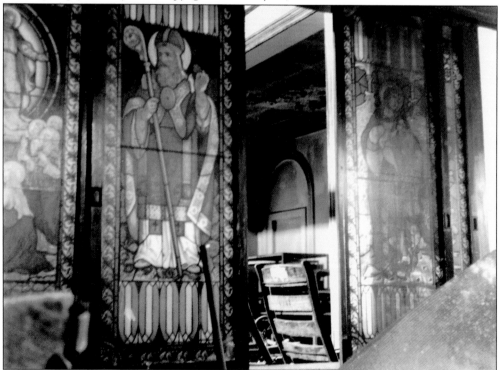

Pictured is the interior of Good Samaritan German Lutheran Church prior to its demolition. (Copyright Anne Kayser.)

Sacred Heart was closed in the early 1980s and was subsequently demolished. (Courtesy David Saunders.)

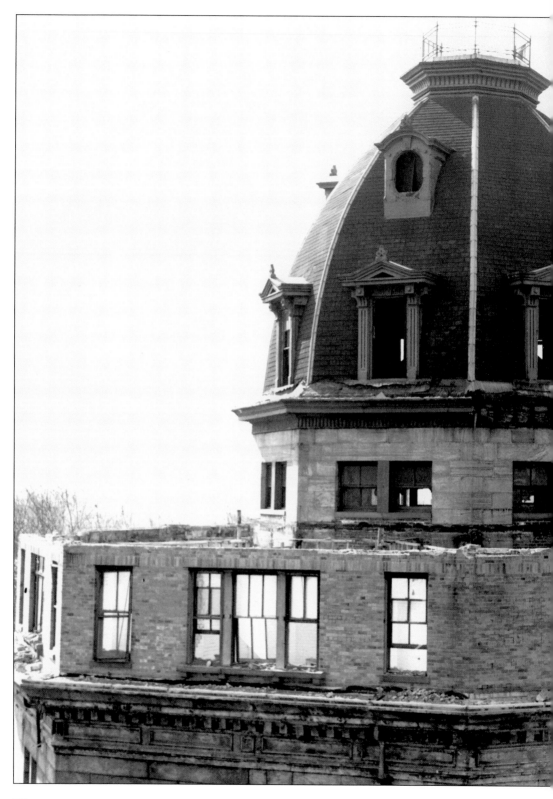

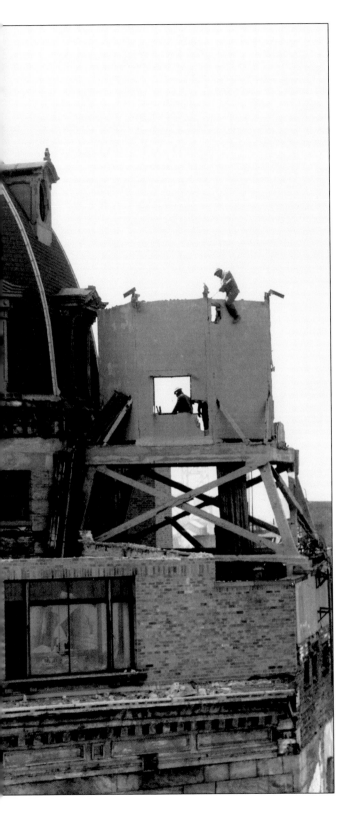

In 1970, the wings of the Octagon were demolished along with the added-on operating rooms on the top floor. (Roosevelt Island Historical Society.)

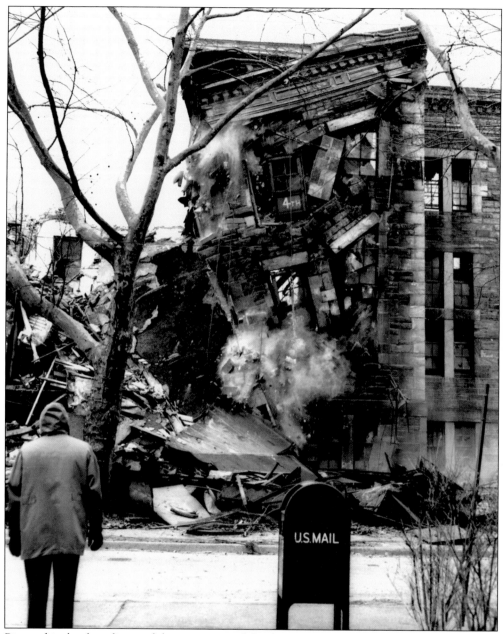

Pictured is the demolition of the west wing of the former New York City Lunatic Asylum and later Metropolitan Hospital. (Roosevelt Island Historical Society.)

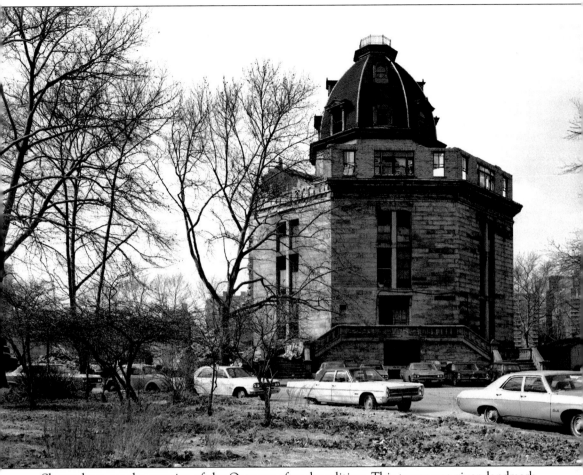

Shown here are the remains of the Octagon after demolition. This tower was given landmark status in 1975. (Courtesy Historic American Buildings Survey, Library of Congress.)

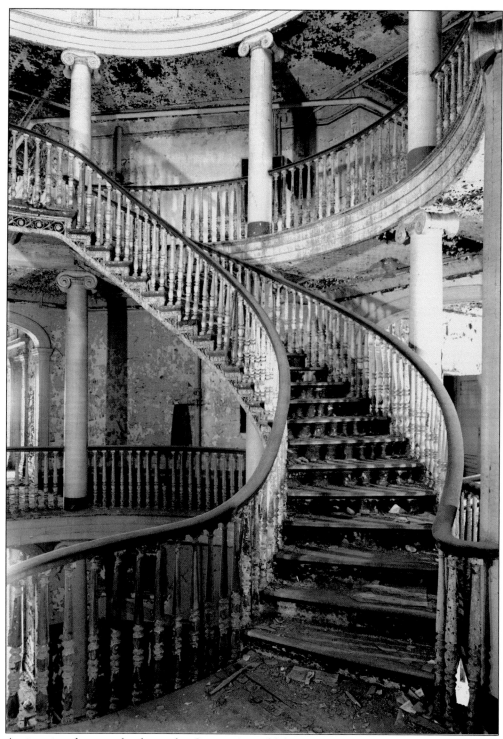

An interior photographs shows the Octagon's world-famous staircase, which appeared to float above the structure. (Courtesy Historic American Buildings Survey, Library of Congress.)

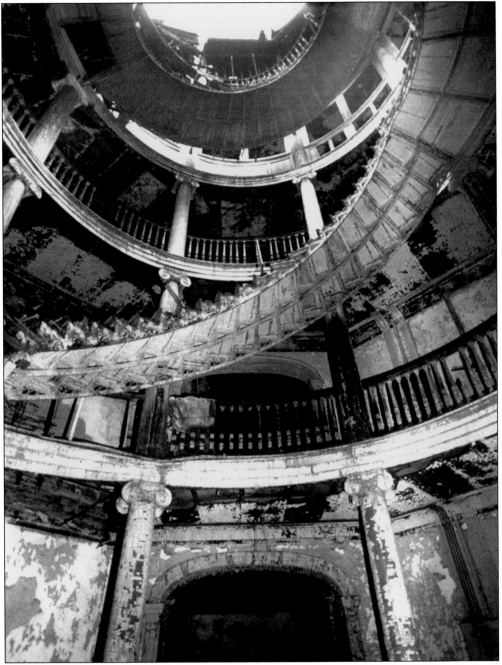

This photograph, taken in 1986, shows the interior of the Octagon after the first fire damaged the rotunda and destroyed the dome of the building, leaving it open to the elements. (Courtesy Roosevelt Island Operating Corporation.)

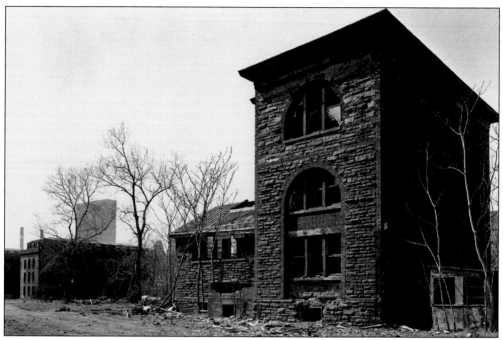

Strecker Memorial Laboratory was a famous medical research facility. Originally, it was a part of Charity Hospital and then became associated with the Russell Sage Institute. It was abandoned in the 1950s. When it closed, specimens (including body parts preserved in formaldehyde), the autopsy table, and refrigerators were left behind. (Courtesy Historic American Buildings Survey, Library of Congress.)

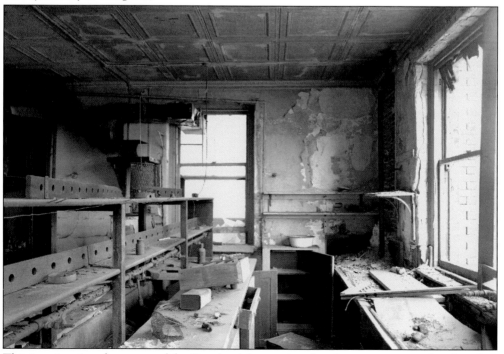

This interior view shows one of the Strecker laboratories after the structure was abandoned.

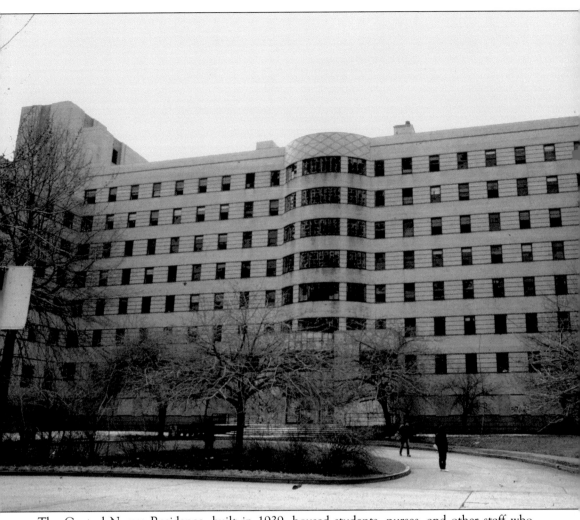

The Central Nurses Residence, built in 1939, housed students, nurses, and other staff who worked in the various hospitals on Welfare Island. It had 605 private rooms and beautiful public spaces. This building was demolished in 2002 to make way for a new housing development called Southtown. (Courtesy the Hudson Company.)

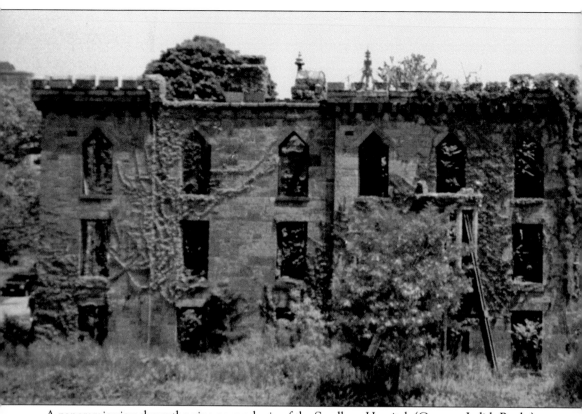

A panoramic view shows the vine-covered ruin of the Smallpox Hospital. (Courtesy Judith Berdy.)

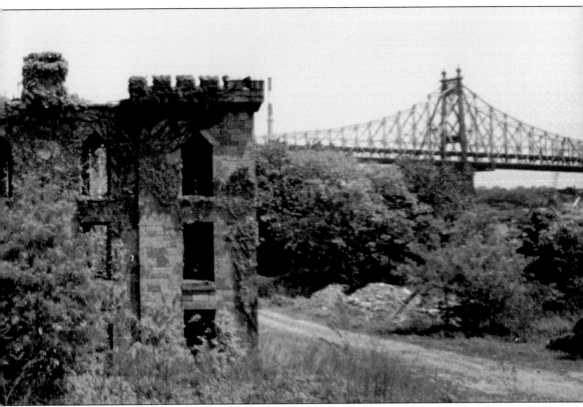

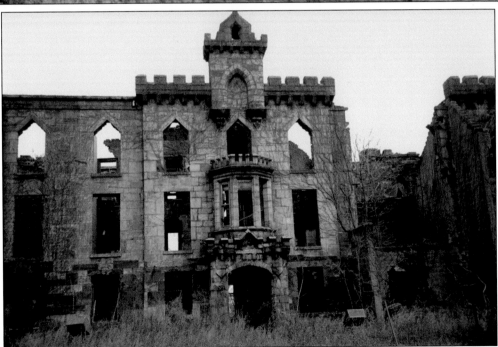

The ruined facade of the original building of the Smallpox Hospital had the same turrets as the penitentiary; both were designed by James Renwick. (Courtesy Judith Berdy.)

Edward J. Logue was the mastermind behind the Urban Development Corporation, which transformed Welfare Island into the residential community. (Courtesy the Municipal Art Society.)

Eight

THE ROOSEVELT ISLAND COMMUNITY PRESENT AND FUTURE

In the 1960s, the city of New York investigated various proposals for the redevelopment of Welfare Island. Mayor Lindsay appointed a committee of city officials and interested citizens to devise a redevelopment plan for the island. Then as now, the city had a pressing need for housing. The redevelopment plan recommended building a mixed-income, ethnically diverse, handicapped-accessible community with two neighborhoods, Northtown and Southtown. The original conceptual design of the community was drafted by architects John Burgee and Philip Johnson. Apartment buildings would be clustered in the center of the island, leaving open, recreational space at both ends of the island. The plan also included commercial space, a parking garage, a school, an automated vacuum sanitation facility, and restoration of six historic buildings. A promenade gracing the island's perimeter would offer walkers opportunities to take in the air and enjoy wonderful views of Manhattan and Queens.

In 1969, Gov. Nelson Rockefeller formed the New York State Urban Development Corporation (UDC) and appointed Edward J. Logue president and chief executive officer to expedite and operate the project. The city leased most of the island to the state of New York for 99 years, and the UDC floated bonds and borrowed money to fund construction of the new community. In 1973, to symbolize its bright future, Welfare Island was renamed Roosevelt Island in honor Franklin Delano Roosevelt.

The first buildings completed were Eastwood, Westview, Island House, and Rivercross. Together, they contain more than 2,000 affordable, government-subsidized units built to house families. In 1975, the first resident moved onto the island. For many years, only the aerial tramway directly linked Roosevelt Island to Manhattan. Instantly, the tramway became the symbol of Roosevelt Island and a popular tourist attraction. It is widely recognized because it was featured in several popular films, including *Nighthawks* and *Spider-Man*.

The first of the historic buildings to be restored was the Chapel of the Good Shepherd. In 1975, it reopened as a community center serving as a general meeting hall and religious home for those of the Catholic and Protestant faiths. Although Blackwell House had disintegrated into a battered shell of a farmhouse, it was restored as a community center. The house sparkled with fresh coats of paint and became a charming place to hold small social events. At the north end of the island, the lighthouse was repaired. Strecker Memorial Laboratory was renovated by the Metropolitan Transportation Authority (MTA) to serve as a power conversion substation for the subway system. The Romanesque exterior and details, even the brilliant blue paint on the front door, were restored exactly to their original state, giving no hint of the utilitarian machinery housed in the interior of the structure. At the south end of the island, City Hospital was demolished and the Smallpox Hospital remains a gothic ruin—its future yet to be determined.

Coler and Goldwater Hospital merged in 1996 to form Coler-Goldwater Speciality Hospital and Nursing Facility. With almost 2,000 patients and residents, this hospital serves the city's need for a long-term care facility and is also a vital part of the island community.

In 1987, a new housing complex called Manhattan Park was built with 800 units of luxury, market-rate apartments and 200 for low-income families, seniors, and disabled persons. It is built around a charming park, across the street from the parking garage and post office. Southtown, the final phase of the residential development, was begun in 2002. This site is slated to hold nine buildings with a mix of affordable and market-rate housing.

The future of the island is bright. The Octagon Tower has been stabilized. The firm of Becker and Becker is planning the construction of a housing complex composed of 500 units; 400 will rent at market value and 100 will rent to low-income families. The Octagon Tower and its 19th-century dome will be restored to serve as the main entrance to a complex consisting of two wings built at right angles to the tower. At the southern point of the island, where the ruins of the Smallpox Hospital stands, is a 10-acre undeveloped site. Many suggestions and proposals for its use have been explored, including one for a public park dedicated to Eleanor and Franklin Delano Roosevelt, but none have come to fruition.

Community groups have contributed much to the island. From the early frontier days to the present, residents take an active interest in their community. More than 50 diverse volunteer groups exist. In 2002, a memorial was dedicated to those residents and firefighters stationed on the island who lost their lives at the World Trade Center on September 11. Just minutes from the rest of the city, Roosevelt Island continues to fulfill its promise of being a small town in the middle of a big city.

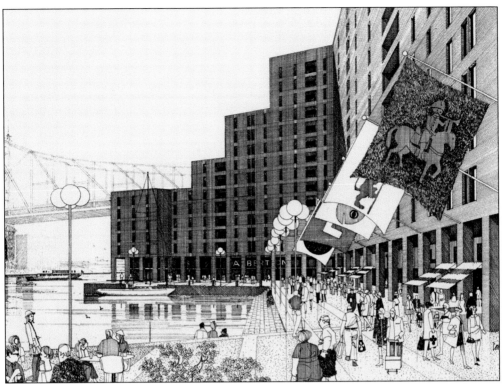

These 1970s drawings depict the future of Roosevelt Island. The drawing above shows a rendering of an apartment house facing Manhattan with a marina and a grand promenade. The marina could not be built because of the fierce currents of the East River. Below is Good Shepherd Plaza, which became the focal point of community activities. (Courtesy New York City Urban Development Corporation.)

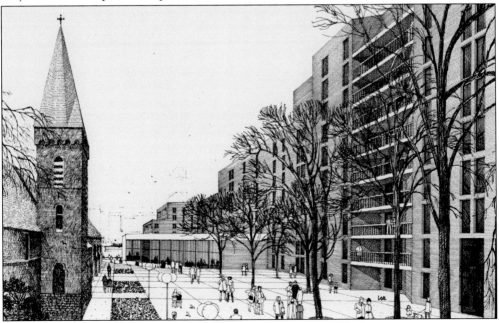

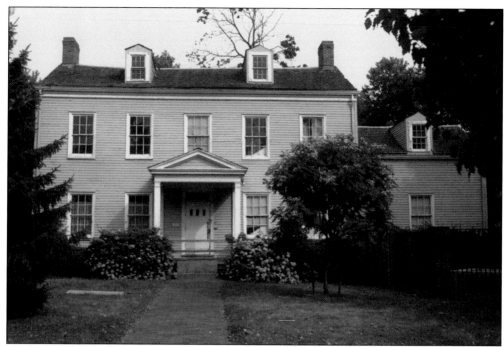

Blackwell House is shown here after its restoration in 1975. It provided a homelike atmosphere for community and social events on the island. (Courtesy Judith Berdy.)

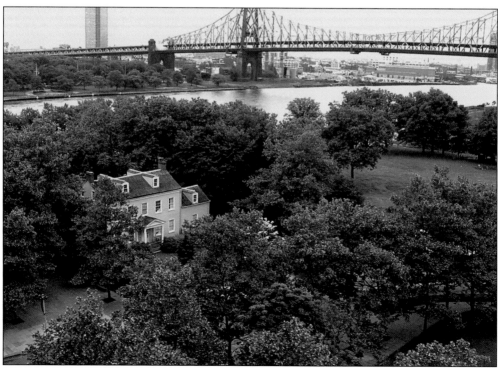

This aerial view of Blackwell House looks toward Queens. (Courtesy the *Main Street Wire*.)

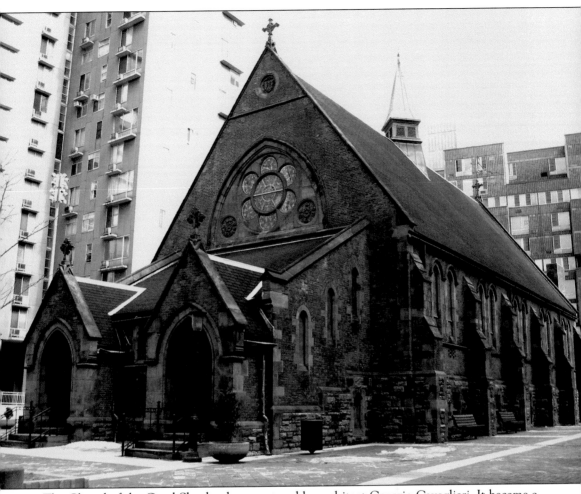

The Chapel of the Good Shepherd was restored by architect Georgio Cavaglieri. It became a community center as well as the home to the Catholic and Episcopalian parishes. It is the most used community space on the island. (Courtesy Maria Harrison.)

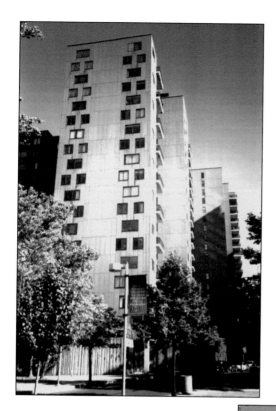

Rivercross, designed by Johansen and Bhavnani, opened in 1975 as a state-subsidized middle-income cooperative residential complex. (Courtesy the *Main Street Wire*.)

Eastwood is a federally subsidized rental complex consisting of 1,004 units on the east side of the island for moderate-income residents. It was designed by Sert, Jackson, and Associates. The bright red accents on the brown, ribbed, block facades have become the theme color for the whole island. (Courtesy the *Main Street Wire*.)

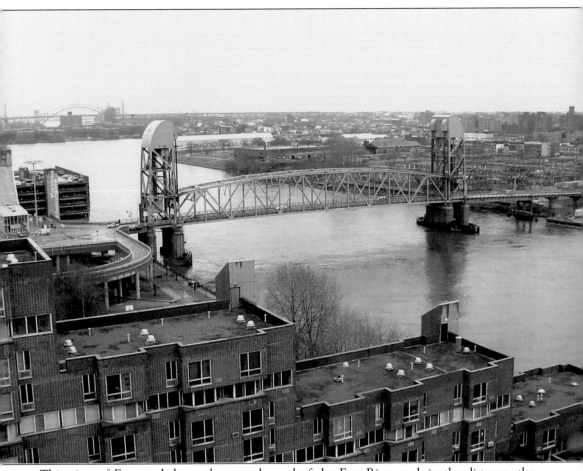

This view of Eastwood shows the east channel of the East River and, in the distance, the Roosevelt Island Bridge, the Hell Gate Bridge, and the Triborough Bridge. (Courtesy the *Main Street Wire*.)

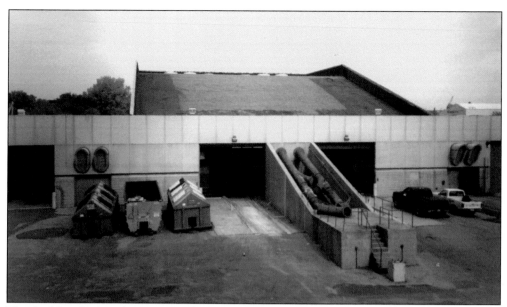

This building houses the automated vacuum system (AVAC), operated by the New York City Sanitation Department. Giant vacuum tubes buried under the streets wisk away all domestic trash generated from the residential buildings to this compacting station. Here, the rubbish is compacted into containers. This unique sanitation method has been studied by city managers from around the world. (Courtesy the *Main Street Wire*.)

Manhattan Park is a residential complex consisting of buildings clustered around a village green. Four are luxury rental units, while the fifth offers 223 federally subsidized units for elderly, disabled, and low-income residents. (Courtesy the *Main Street Wire*.)

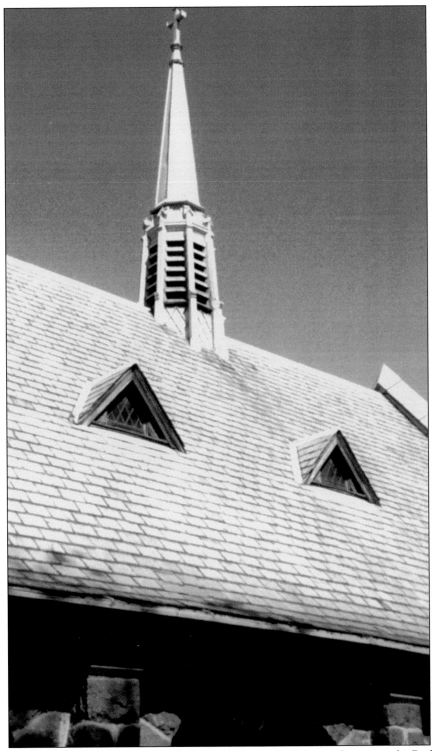

Here is a view of the copper spire of Holy Spirit Church, which is now known as the Redeemed Christian Church of God (International Chapel). (Courtesy Judith Berdy.)

Opened in 1991, Octagon Park consists of a waterfront promenade, a community garden, a baseball diamond, and a soccer field. This magnificent photograph was taken from "the Prow"

A brushed-aluminum colonnade invites visitors to enter and explore Octagon Park. (Courtesy Judith Berdy.)

on the west side of the promenade. (Courtesy Judith Berdy.)

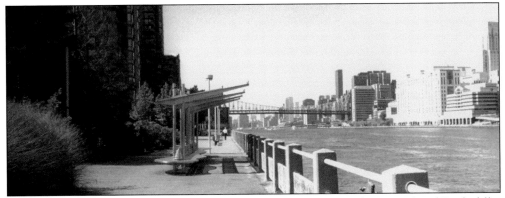

The Octagon Park promenade offers views of Manhattan. New York Hospital and Rockefeller University are just across the river. (Courtesy Judith Berdy.)

On the rocks, next to the promenade facing Manhattan, sculptures delight the viewer. This grouping is titled *The Marriage of Money and Real Estate*. It is the work of sculptor

Tom Otterness. (Courtesy Maria Harrison.)

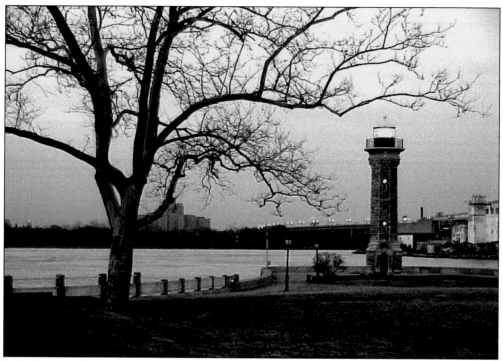

Lighthouse Park, with its recently restored lighthouse, provides a quiet oasis at the northern tip of the island. (Courtesy the *Main Street Wire*.)

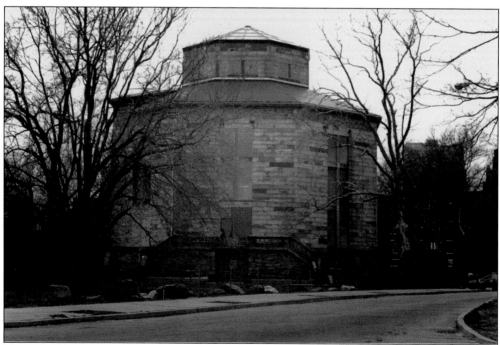

Arsonists set fire to the Octagon Tower on two occasions. This photograph shows the building before the second and more damaging of the fires. (Courtesy the *Main Street Wire*.)

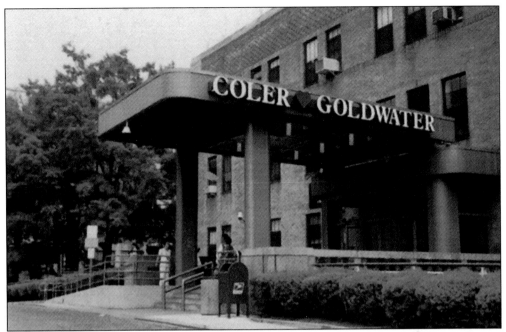

In the 1930s, the city decided to build a hospital park on the island, consisting of seven modern facilities. Only two were constructed. Goldwater, with 986 beds, opened in 1938, and Coler, with 1,025 beds, first received patients in 1952. The hospitals merged in the 1990s. They are now operated by the Health and Hospitals Corporation. Their mission is to provide long-term care to all residents of New York City. (Courtesy Coler-Goldwater Specialty Hospital and Nursing Facility.)

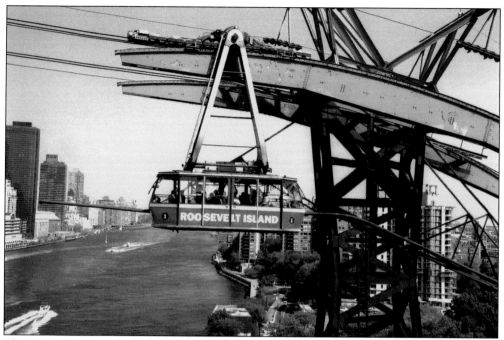

The Roosevelt Aerial Tramway opened in 1976 as a temporary mode of transportation to the island from Manhattan while the subway was being constructed. The subway opened in 1989, but the tramway remains because of its popularity with the general public. (Above, courtesy Vicki Feinmel; below, courtesy Maria Harrison.)

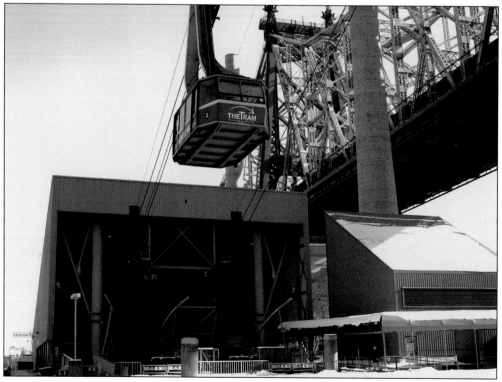

This view between subway cars was taken at the opening of the subway station on Roosevelt Island, October 29, 1989. (Courtesy Judith Berdy.)

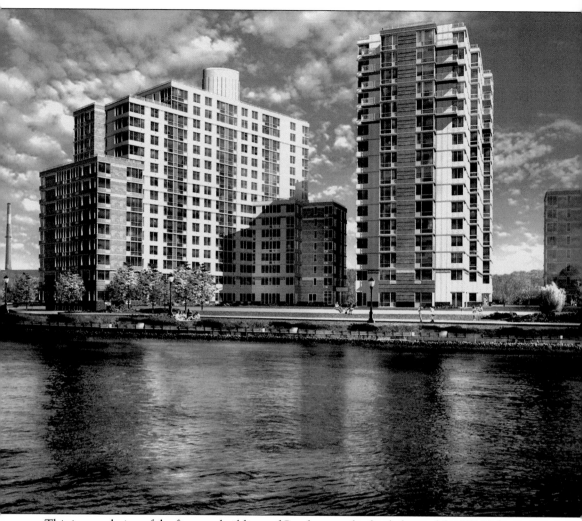

This is a rendering of the first two buildings of Southtown, the final phase of the UDC's housing project, on a 16-acre site. (Courtesy the Hudson Companies and the Related Company.)

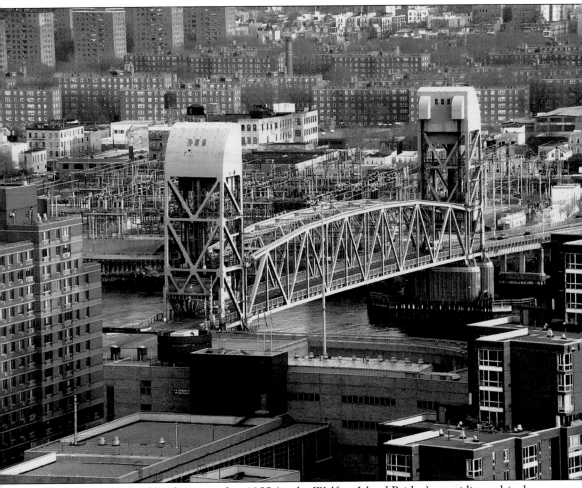

The Roosevelt Island Bridge opened in 1955 (as the Welfare Island Bridge), providing vehicular access to the island from Queens. This bridge is a vertical bridge, which can rise from 40 to 100 feet above the waterline to allow large ships to pass underneath. The bridge transverses the east channel of the estuary known as East River. (Courtesy the *Main Street Wire*.)

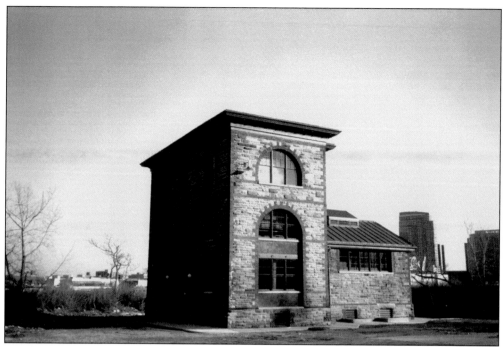

Strecker Memorial Laboratory was restored and rebuilt in 2000. The interior was outfitted to house electric converters for the New York Transit Authority. The exterior was beautifully restored to its appearance during its prime years. (Courtesy Page Ayers Cowley, Architects.)

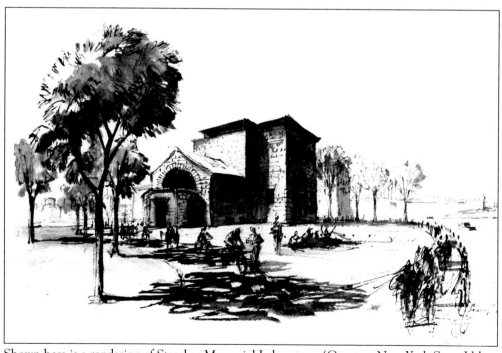

Shown here is a rendering of Strecker Memorial Laboratory. (Courtesy New York State Urban Development Corporation.)

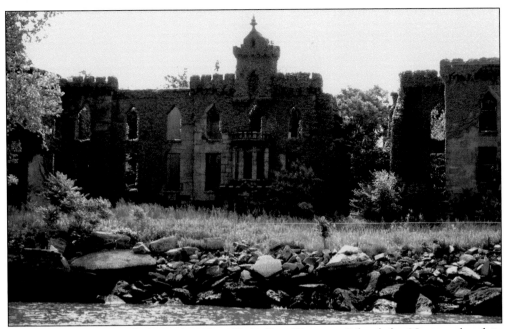

The Smallpox Hospital, later the New York City Training School for Nurses, closed in 1955. The abandoned building was later reinforced and now stands as a stabilized ruin. (Courtesy Maria Harrison.)

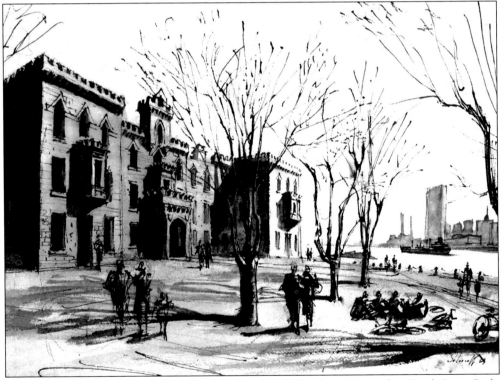

Pictured is a 1970 architectural rendering of a restored Smallpox Hospital at South Point Park. (Courtesy New York State Urban Development Corporation.)

South Point Park, at the southern tip of the island, opened to the public in the spring of 2003, after being closed for many years. (Courtesy Maria Harrison.)

South Point Park is the last undeveloped refuge for wildlife. Many nesting birds can be seen in the lush vegetation. It is a wonderful passive park for residents and visitors to enjoy. (Courtesy Maria Harrison.)

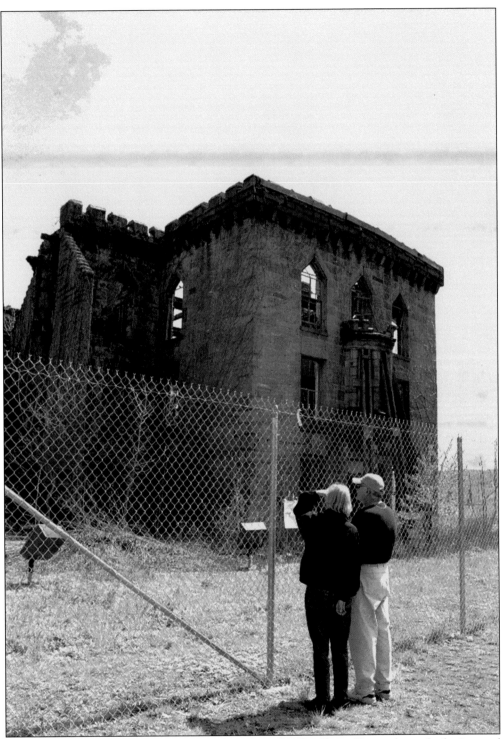

Visitors are seen here exploring the park. When the Smallpox Hospital was built, it stood just a few feet from the water's edge. Later, landfill enlarged the island by eight acres. (Courtesy Maria Harrison.)

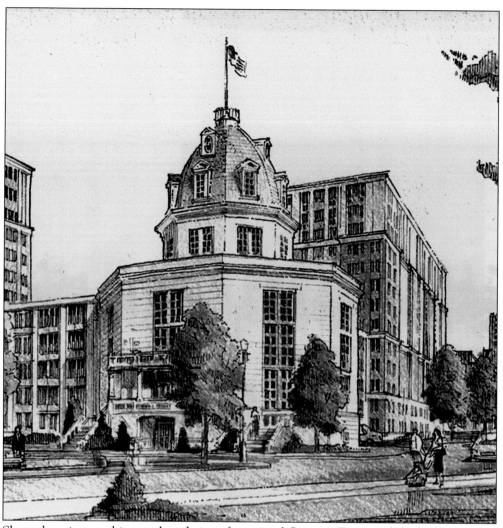

Shown here is an architectural rendering of a restored Octagon Tower and the building of two wings containing 500 apartments. (Courtesy Becker and Becker Associates.)

This drawing illustrates a proposal to build a hotel at the southern tip. This area has now been set aside for the development of a park. (Courtesy Southpoint Development.)

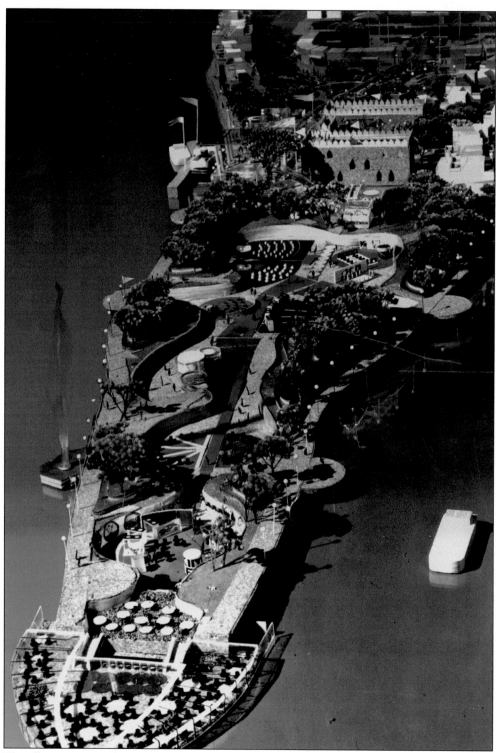

This illustration was for a 1970s proposal to build an amusement park on the island. (Courtesy New York State Urban Development Corporation.)

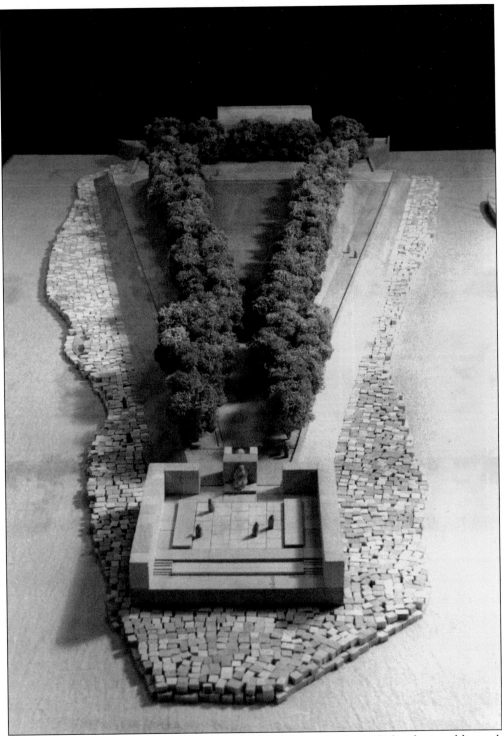

A photograph taken in 1973 shows a model of a design by Louis Kahn for a public park commemorating Franklin Delano Roosevelt. The park proposed for the southern tip of the island never came to fruition. (Courtesy New York State Urban Development Corporation.)

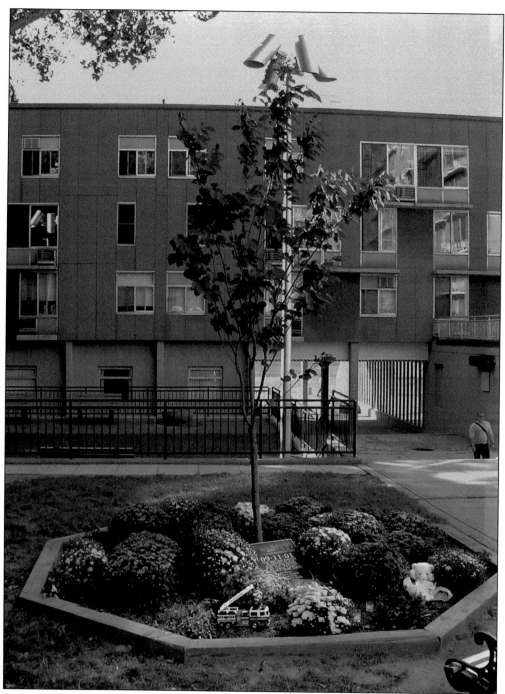

In April 2002, the Roosevelt Island community held a ceremony to unveil a plaque and dedicate a cherry tree to the island residents and firefighters from the New York Fire Department Special Operations Command who lost their lives in the September 11, 2001 attack on the World Trade Center. (Courtesy Vicki Feinmel.)